DRAWING
MATTERS

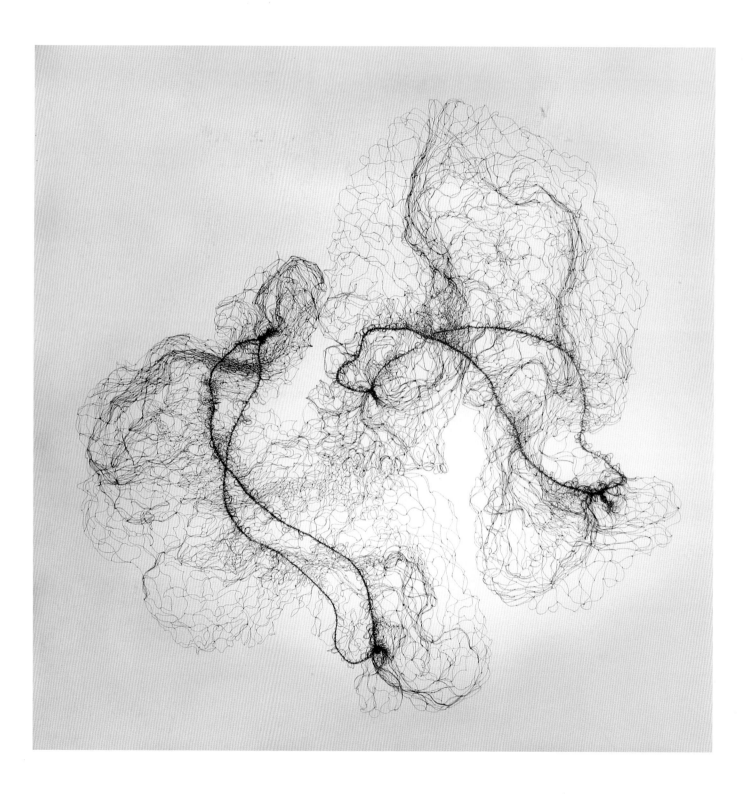

DRAWING MATTERS

Jane Stobart

A & C BLACK
London

First published in Great Britain in 2006
A & C Black Publishers Limited
38 Soho Square
London W1D 3HB
www.acblack.com

ISBN-10: 0-7136-7084-3
ISBN-13: 978-07136-7084-4
Copyright © 2006 Jane Stobart

CIP Catalogue records for this book are available from the British Library and
the U.S. Library of Congress.

Typeset in 12 on 15pt Celeste
Book design: Susan McIntyre
Cover design: Peter Bailey
Copyeditor: Julian Beecroft
Project Manager: Susan Kelly
Editorial Assistant: Sophie Page

Printed in China

FRONTISPIECE Two Hair Nets No 2, *Susie MacMurray, 150 cm x 150 cm, pen on paper,
2005. The artist says: 'I use the process of drawing to develop a more intimate
relationship with the physical materials which I use in my work. My practice has
its roots in the meticulous, repetitive discipline of musical training and in the
transience of sound. My drawings explore the character and substance of fragile,
ephemeral materials.'*
TITLE PAGE *Glenn Holman, giant Conté drawing (see p. 55).*
CONTENTS PAGE *David Nash RA, Fine Oak, Marsh Lane, A1 (see p. 98).*
PAGE 6 *Jane Stobart, Old Bell (see p. 35).*

CONTENTS

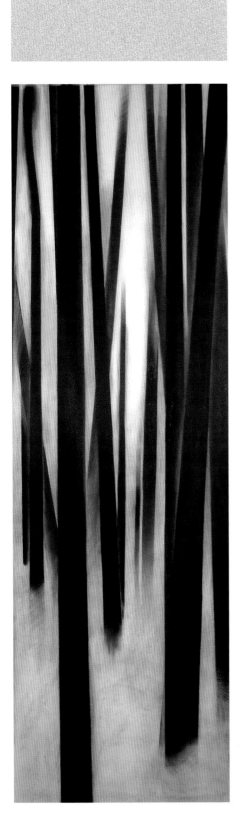

Acknowledgements

Thank you to all the artists featured in this book, who so generously allowed me to include their work as well as their wisdom. I would also like to thank the following for their help and support:

Joanna Banham, Barbara Easteal, Pat Gibberd, Adrian Glew, The Donald Rodney Foundation, Great Art catalogue, Christine Kennedy, Anne McIlleron, Tracey O'Brien, Mustafa Sidki, Diane Symons, Tate Britain, Graham Young.

This book is dedicated to
Edith and Kathy Stobart,
two inspirational women

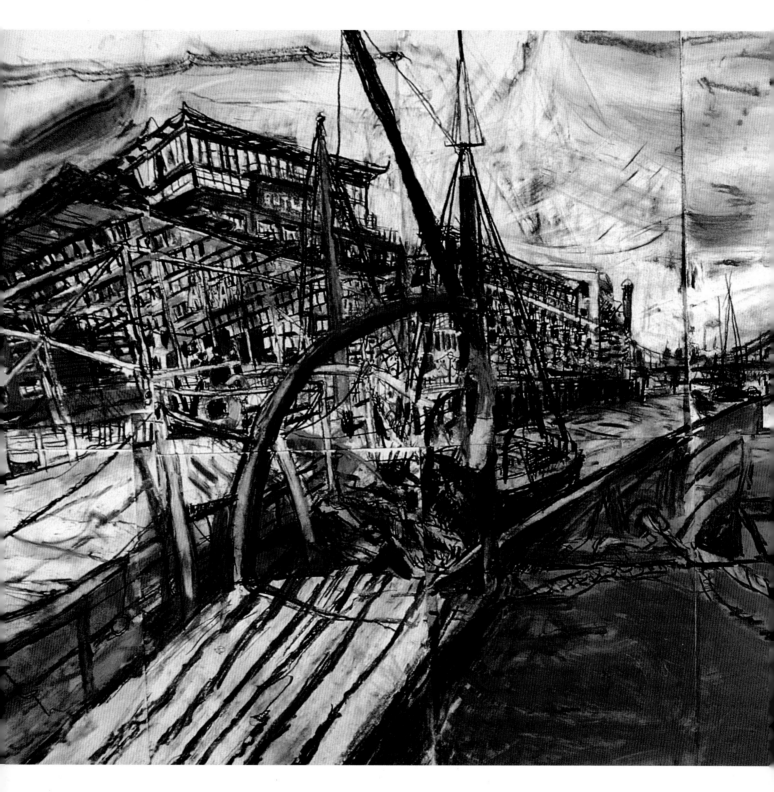

Hannah Murgatroyd MA (RCA), Tower Bridge from Shad Thames Moorings
*(2005), charcoal and pastel drawing on paper, 150 x 80 cm (60 x 32 in.). This
image was drawn on location within the space of a day. I allowed the scene
to grow, adding paper as I drew from the flat bed of one of the houseboats
moored at Shad Thames. This is part of a series of the River Thames.*

INTRODUCTION

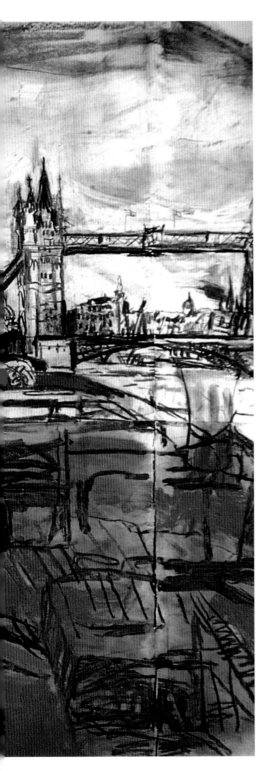

Even in these high-tech days, the ability to express oneself through drawing remains a passion for many people. Despite the historical significance of drawing across many centuries as a foundation for artistic endeavours, it has been treated somewhat as the poor relation of the art world in the latter part of the 20th century, where much of the emphasis has been on painting, sculpture and the video arts. Drawing classes have been dropped in some art schools, where the discipline is sometimes seen as an outmoded activity, at odds with the conceptual emphasis of some courses. However, this has now begun to change, with more exhibitions dedicated to drawing and a growing number of high-profile drawing awards. There is an annual event staged throughout the UK called 'The Big Draw', where galleries, schools, colleges and museums throw open their doors for a weekend and invite the public to participate in drawing installations, assisted and overseen by practising artists. There are a number of high-level and postgraduate drawing courses springing up in art schools around the UK; another positive indication of the growing recognition of this quiet area of fine art.

As a teacher, I meet many full-time, part-time and serious 'recreational' students with a love of drawing and a keen desire to improve their understanding and skills. The aim of this book is to increase awareness of the considerations that go toward making inspired drawing. Selected artists generously discuss their relationship to this area of their work, be it as a primary activity or as something secondary to their main creative specialism. The very personal way in which artists and students use their sketchbooks is the subject of another section, with examples included of work usually deemed personal and private.

There are also many tips and suggestions for working in a wide range of materials, with ideas for approaches to making drawings and advice on composition and perspective. The wealth of concepts and intentions that can lie behind the creation of a single piece of work are discussed, with some stunning examples. I have chosen works by a variety of people for whom drawing plays a vital role in both their individual works and their overall creative development.

The book concludes by making suggestions for creating your own inventive, thematic sketchbooks and creative projects, which will result in a series of investigative drawings and an exciting body of work.

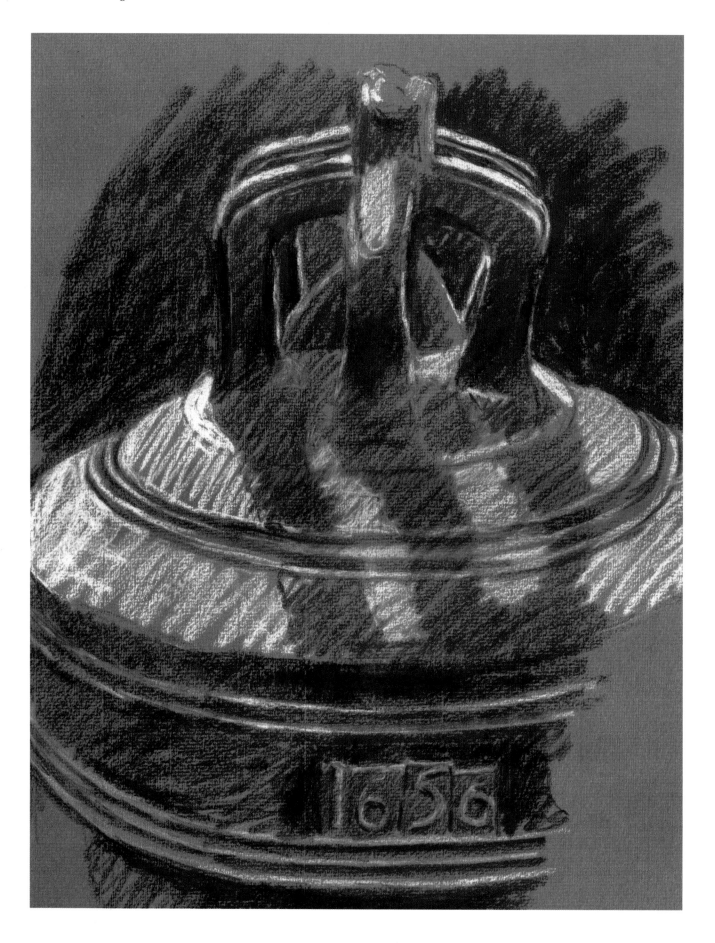

<table>
<tr><td>*Chapter 1*</td><td>

MATERIALS, METHODS AND PAPER

</td></tr>
</table>

This chapter looks at a wide range of drawings which have been greatly influenced by the choice of medium. The materials you draw with and what kind of paper you choose are of fundamental importance to the quality of a drawing. For example, working on a sheet of brown wrapping paper can result in an interesting piece of work and will make you think differently, simply because you are not starting from the usual white base. Stepping outside of your comfort zone and trying a less familiar medium or scale of material, such as a fat graphite stick or a brush and wash, will transform the marks you make and will challenge you to create a different sort of drawing. It is well worth experimenting with a range of materials and approaches, on all types of paper.

1.1 Graphite *of varied types and girths; jumbo sharpener; 'peel-down' eraser pencil.*

1.2 RIGHT *Robert Bramich, tonal* **graphite** *drawing, 7.5 x 10 cm (3 x 4 in.).* See p.12.

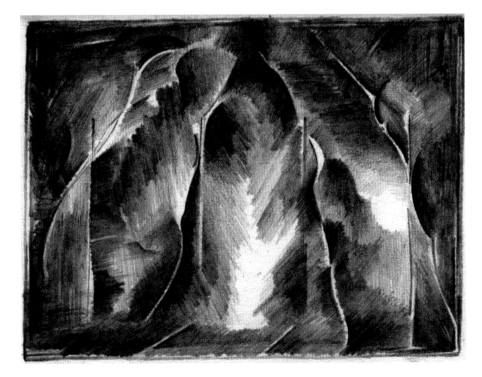

1.3 OPPOSITE *Jane Stobart, black and white* **Conté** *on mid-tone* **Ingre** **paper***, A3 (420 x 297 mm).* See p.16.

Buying materials

Stocking up with artists' materials can be an expensive undertaking. However, most college shops will offer a slight discount, and at the back of this book I have made recommendations for buying materials by mail order, which in my experience is often the most economical way of obtaining the best quality on a budget. One thing is for sure, you will not need to invest in everything you see; start with a few classic drawing materials, such as a soft graphite stick, some charcoal, a putty rubber and a few well-chosen colour pastels. Buy individual sticks and tubes and try not to be seduced by boxed sets. Chapter 2 makes suggestions for which colours to buy (see fig. 2.14).

Water pots and palettes can be purchased at a cost, but jam-jars and old china plates or pieces of plastic are a free alternative.

Drawing materials and their application

- **Graphite** is available in a range of shapes and sizes, offering an alternative to the usual wooden-clad pencil we all know and love. I favour solid graphite in pencil form but with no wooden casing, just a thin, plastic outer shell. Stubby graphite sticks come in various

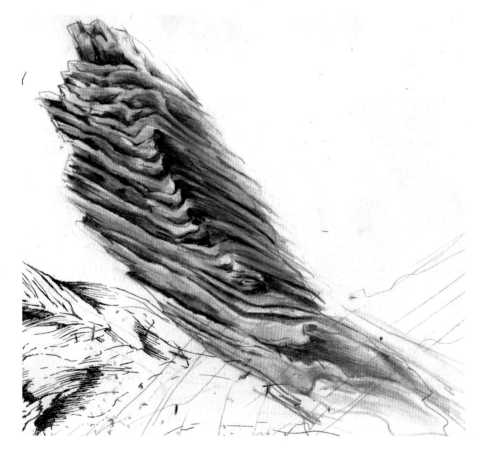

1.4 Jackie Newell, *study of wood, drawn with* **coloured pencils***, 11 x 11 cm (4¼ x 4¼ in.).*

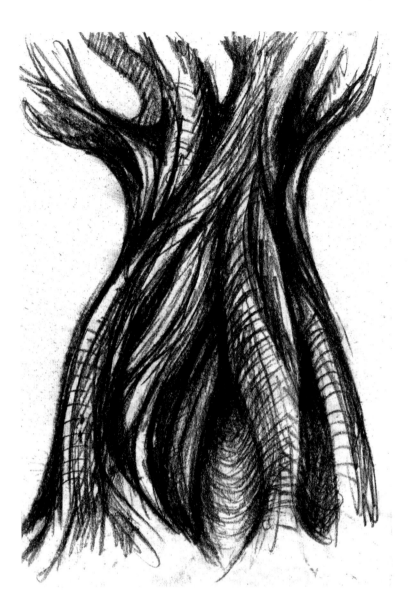

1.5 Ceiren Bell, Tree 1, **charcoal**
drawing, 21 x 14.8 cm (8¼ x 5¾ in.).
See p.15.

1.6 Richard Morgan, detail of A4 life
drawing using **charcoal** *and* **putty**
rubber, *A2 (594 x 420 mm). See p.15.*

contours and are available in grades ranging from B to 8B. Mammoth sharpeners are really useful for all the fatter sticks of graphite and for pastels, should a point be required (see image 1.1). Conté produce a 'black lead' drawing pencil which offers an intense, rich, matt black.

• With **coloured pencils** it pays to buy very good quality, which will contain a degree of wax, making it possible to mix colours together to create rich, complex blends. This will save you buying the full set, which can often number as many as 72 pencils (see Chapter 2, Colour Mixing, p. 38). For drawings larger than A3 (420 x 297 mm), coloured pencils, with their small scale of mark, are rather too timid, though some manufacturers offer thicker pencils with the larger girth of 10 mm, or sticks (without the wooden casing), for increased coverage. Regular-size pencils are perfect for small studies if you are working in a museum or some external location; a 'drum' sharpener (with a waste box) is recommended, and often insisted upon, if you are drawing in a public place.

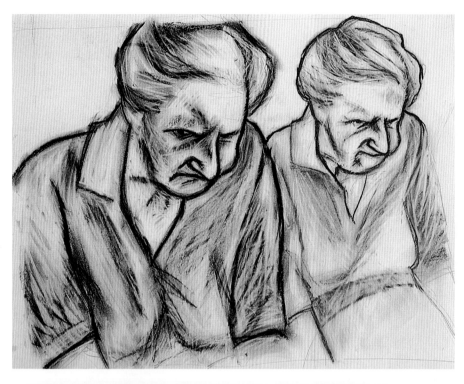

1.7 *Judy Groves*, The Aunts,
charcoal *on lining paper (detail)*
with the aid of paper blending stick,
61 x 45.5 cm (24 x 18 in.). See p.16.

1.8 *Jane Stobart*, Victorian Sewer,
compressed charcoal *on mid-tone*
Ingre paper, 16 x 23 cm (6¼ x 9 in.).
See p.16.

1.9 Jane Stobart, Bell Study, **chinagraph pencil**, *12.5 x 9.5 cm (5 x 3¾ in.). See p.16.*

1.10 Clutch and propelling pencils. See p.18.

- **Charcoal** is relatively cheap and is a versatile drawing material; the depth of the black will vary, depending on the surface of the paper you work on. On a smooth surface ('HP' – see Paper Terminology, p.26), charcoal can look grey and ghostly, while a slightly textured paper ('NOT' or 'Rough'), will enable you to achieve richer blacks. Charcoal can be bought in fine, medium and thick grades, as well as 'extra thick' sticks measuring 14 mm (½ in.) across, for larger drawings. Printmaking suppliers sell large chunks of charcoal (used in etching), excellent for massive drawings. Charcoal is also available in pencil form with a handy 'peel-down' wrapped stick, which saves on sharpening. Willow charcoal is the most popular kind.

- A soft **putty rubber** is an essential drawing tool and can be rubbed through a solid area of charcoal, allowing you to work back almost to the original paper colour; this is known as subtractive drawing. It can be used for adding highlights without the necessity of using chalk. Putty rubbers will not lift compressed charcoal or Conté with the same ease as they will with charcoal. Slightly textured paper is recommended for charcoal ('NOT' or 'Rough' – see Paper Terminology on p. 26).

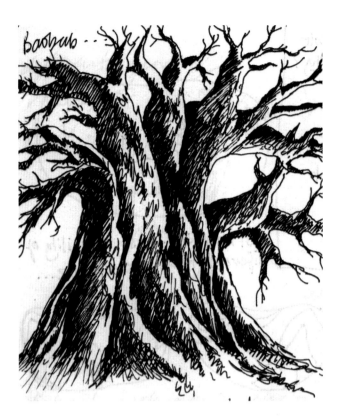

baobab ..

1.11 Ceiren Bell,
Tree 2, ***Rotring pen
and ink**, 10 x 10
cm (4 x 4 in.).
See p.18.*

- A **paper-blending stick** (sometimes called a 'torchon') can also be used as a drawing tool, to blend or to draw directly into charcoal and pastel. (See fig. 1.7.)
- **Compressed charcoal** seems to have more of the qualities of chalk pastel or Conté sticks than regular charcoal. It can be purchased in a range of greys as well as white and a dense black. These sticks have impressive coverage and can be blended together. As with charcoal, drawings will need to be 'fixed'. (See fig. 1.8.)
- **Conté** is the trade name for a dense pastel. Black Conté is richer and much darker than charcoal. It is also available in white, a range of grey tones and a wide range of colours. Sandpaper is a quick and effective way of sharpening Conté sticks, pastels and pencils, if a point is desired. (See fig. 1.3.)
- **Fixative** seems to be a complicated issue when you browse the pages of a mail-order catalogue, with each brand making different claims. I invest in the best I can afford that is suitable for charcoal. Many students use hairspray, although the long-term effects on a drawing are untested. See Chapter 10 for more details on fixative types and health and safety issues when using airborne sprays.
- **Chinagraph pencil** is excellent for making assertive line or tonal drawings and has the great advantage of not requiring fixative. I carry one of these around with me for working in small sketchbooks when I'm commuting, etc. It offers a strong, dynamic black and has virtually

*1.12 **Reed pens.** See p.18.*

*1.13 Jane Stobart, Chinese brush drawing from solid **Chinese ink blocks** (see below). See p.18.*

*1.14 **Chinese brushes**, inks, grinding stone. See p.18.*

*1.15 RIGHT Chris Cook, **ballpoint pen** drawing from his 'Travels on the Tube' sketchbook, 14.8 x 10.5 cm (5¾ x 4¼ in.). See p.19.*

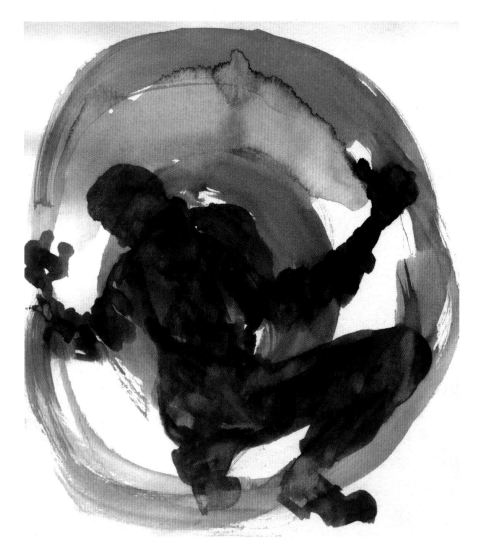

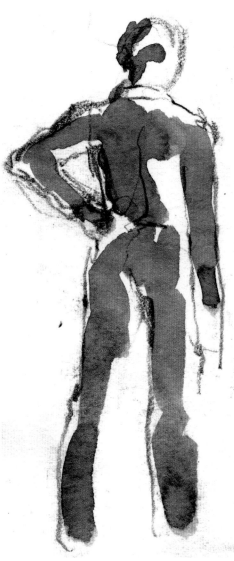

1.16 *Jane Stobart*, Bell Founder, ***ink and brush*** *drawing, 11 x 11 cm (4¼ x 4¼ in.).*

all of the tonal range of charcoal or Conté. It is also available in white and a limited range of colours. You can buy chinagraph in 'peel-down' pencil form, which requires no sharpening. See fig. 1.9.

• A range of **'clutch' or propelling pencils**, designed to hold specific thicknesses of graphite and charcoal leads, pastels, etc., can be obtained from the Great Art catalogue. They are really handy for drawing on location, as the stick of drawing material can be retracted for protection in transit. See fig. 1.1.

• **Ink** with pen, brush or dip-in stick (obtained from the garden!) can lend sensitivity or bold dynamics to a drawing, depending on the chosen implement. A wide variety of reed and bamboo pens and liquid Chinese ink can be obtained from the Great Art catalogue, in addition to Chinese watercolours. Alternatively, you can make your own pens by sharpening various thicknesses of bamboo. See figs. 1.11, 1.12 and 1.13.

• Blocks of solid **Chinese inks**, beautifully decorated with gold embellishments, can be obtained in a variety of colours, which need to be ground (rubbed hard) into a little water, using a special grinding

1.17 *Jane Stobart*, David, *pencil line drawing with **watercolour wash**, 10.5 x 4.5 cm (4¼ x 1¾ in.).*

*1.18 ABOVE Ceiren Bell, **wax and ink wash**, 13 x 6.5 cm (5 x 2½ in.).*

*1.19 RIGHT Jane Stobart, **masking fluid** with watercolour. See p.21.*

*1.20 Linda Wu, drawing with **paint** (detail of A1 [840 x 594 mm] drawing).*

stone (often sold with the blocks of ink). Use the resulting ink with the very tip of a Chinese brush, which can be obtained extremely cheaply from any branch of The Works (see 'Suppliers' on p.126). (See fig. 1.14.)

- **Ballpoint pens** can make interesting and surprisingly sensitive drawings using a scribbly, searching line. The mark will be unvaried but can be used with a delicate touch to seek out form and contour.
- **Drawing inks** are either water-based, and can be therefore diluted with tap water, or shellac-based, and will slightly separate when thinned with regular water, giving an interesting effect. 'Distilled' water (obtained by melting the ice that forms on the walls of some freezers) will dilute shellac-based ink without separation occurring.
- Adding a thin, watery **wash of colour** or tone to a pencil line drawing adds a suggestion of solidity to the form, or a light source, without obscuring the structural line. (See fig. 1.17.)
- **Wax and wash** is a method favoured by sculptor Henry Moore in his drawings. Highlights added with a candle or white wax crayon will act as a resist when a mid to dark-tone wash of watercolour or ink is

1.21 OPPOSITE *Margaret Steiner,* St Magnus-the-Martyr, London, *technical pen with black waterproof ink, water-soluble ink, diluted household* **bleach**, *A4 (297 x 210 mm). See p.22.*

1.22 BELOW *Jackie Newell,* Skull, **chalk pastel** *drawing, 14.8 x 21 cm (5¾ x 8¼ in.). See p.22.*

painted over the area. There is always an element of surprise when you work with this method, as the wax marks will only reveal themselves when the wash is applied. Black wax crayon or black chinagraph pencil line can be added to define darker contours, shadow, etc., before or after applying the wash. See fig. 1.18.

● Another excellent water resist is **masking fluid**, traditionally used by watercolourists to retain the highlights in a painting (watercolour painters rarely use white paint). This rubber solution can be painted onto paper, and when dry it can be covered with a wash of paint or diluted ink. When the wash is thoroughly dry, the masking fluid can be rubbed off with your finger or an eraser to expose the paper underneath. See fig. 1.19.

● **Paint** used in a drawing can be a rapid way of adding tone or colour, a suggestion of form or dynamic line. 'Artist's quality' watercolour pans and tubes are moist and pigment-loaded, which means they'll last longer. Quality of paint will be indicated by price. Decorating brushes in widths of an inch or larger (used for glossing or priming doors, etc.) can be bought more cheaply than artists' paintbrushes of a similar size; they are great for

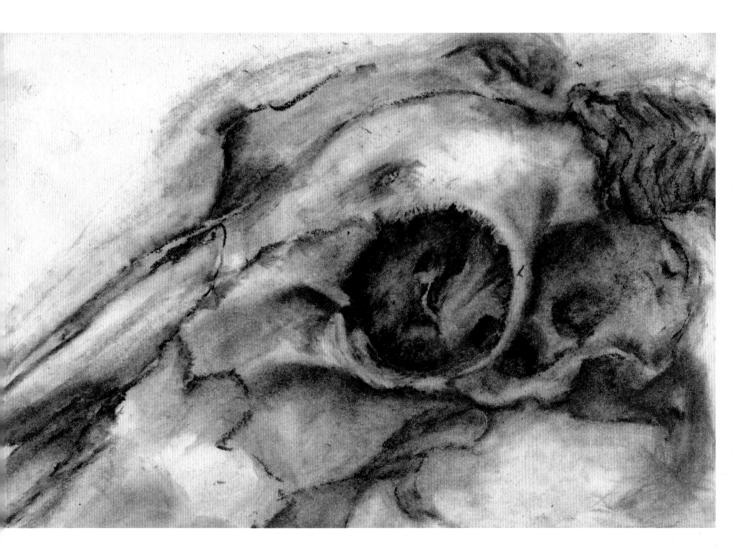

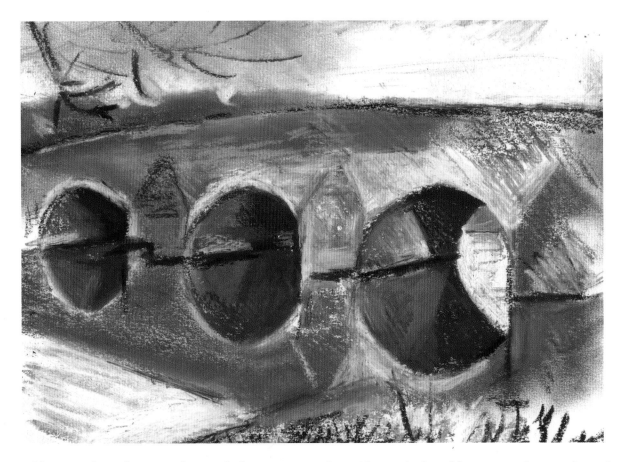

adding quick washes to indicate a light source or colour. Alternatively, add paint washes using a small sponge. See figs. 1.20 and 2.21.

- Household **bleach**, diluted with water, will remove areas of water-soluble ink to create highlights, etc. Blot thoroughly when you have obtained the required effect. Remember always to use bleach in a well-ventilated area, wearing protective clothing and rubber gloves. See fig 1.21.
- **Chalk pastels and oil pastels** are as different as chalk and cheese! The potential for subtlety and delicacy using chalk pastels in a colour drawing can be very seductive. Compare with this the dynamic marks that can be achieved using oil pastels. Good-quality pastels of either type will allow you to adjust colour values as the drawing develops.
- With **chalk pastels**, you really will get what you pay for. Expensive pastels are likely to be pigment-loaded, enabling you to mix and adjust the colours as your drawing develops. Cheaper brands rapidly reach a point where the surface of the drawing becomes shiny, making it impossible to continue. Chalk pastels can be obtained in a variety of thicknesses ranging from dainty sticks to big fat cigar sizes. Buy fewer colours of a good quality product rather than a big box of cheaper pastels (see p. 38 for advice on buying colour materials). It is essential to use fixative, both during the drawing and when it is finished. Slightly textured paper is recommended for chalk pastel work ('NOT' or 'Rough' - see Paper Terminology, p. 26).

1.23 Chris Cook, Study of Bridge, *oil pastels, 20 x 29 cm (8 x 11½ in.). See p. 24.*

1.24 OPPOSITE Anne-Marie Foster, Cartographic Bulb, ***mixed-media** drawing using rollerball pen, magic marker, pencil, pasted paper and water-based relief printmaking ink, 42 x 41 cm (16½ x 16 in.).*

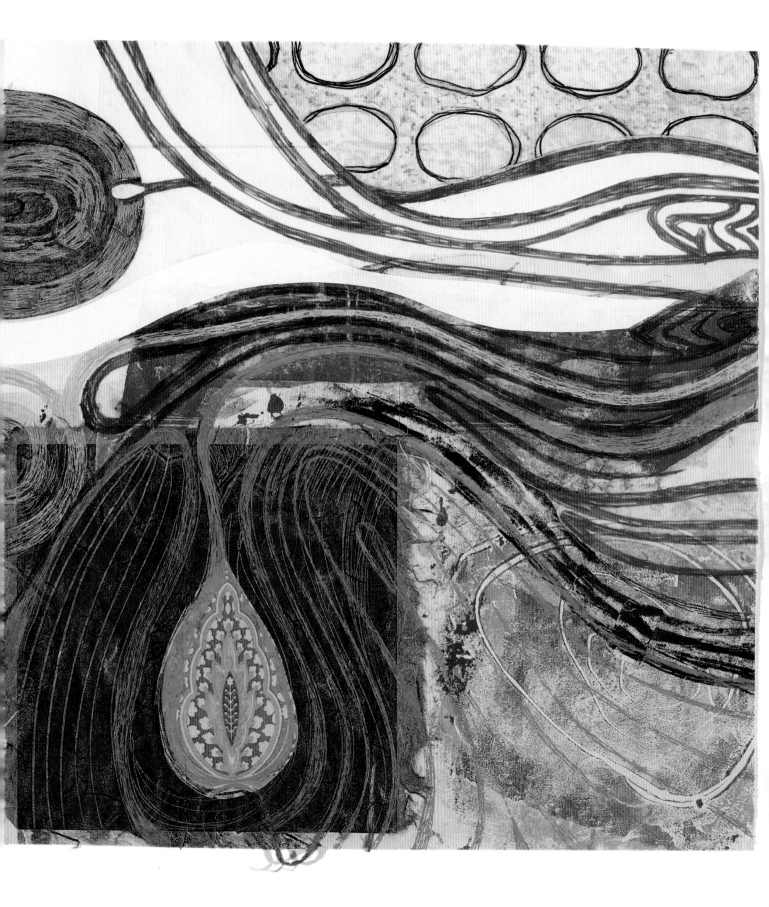

- **Oil pastels** offer a high opacity that will enable you to adjust colours as your drawing develops. There is no excess oil in these pastels, and thus they can be used on any paper without fear of oil-bleed. This medium will set in a few hours, no fixative is required. See fig. 1.23.
- **Water-based pastels** look and respond like oil pastels, when in fact they contain no oil and are completely water-soluble. They can be smudged and blended with a brush, a sponge or your fingers dipped in water. See fig. 1.25 (image on right).
- **Oil bars** are genuine oil paint in stick form and can be blended together with a brush, fingers, a palette knife or a blender stick bought especially for the purpose. Despite having all the qualities of oil paints, these can be used on any paper (as well as canvas) without any oil-bleed whatsoever, making them an excellent drawing medium. Oil bars are available in a variety of stick widths and, unlike regular oil paints, they become touch-dry overnight. They will be completely dry in around three days. See fig. 1.26.
- Several great artists of the 20th century experimented with **collage** or **montage** in their painting and drawing. Montage is the term for torn or cut areas of pre-printed papers, such as magazine photographs, advertisements or text matter, incorporated into an image. Collage is the same technique, but the papers used are usually flat colours such as tissue or sugar paper. Matisse invented collage in his well-known images from the *Jazz* series and *The Snail*, using pre-painted sheets of paper which he cut into shapes and adhered to the canvas.
- **Glue** in stick form offers a dry consistency which is excellent for sticking lightweight papers (the lack of water content will not unduly stretch the paper, thus cutting down on 'cockling'). The best brand is more or less acid-free, which means that your work will not deteriorate over time; check this with your supplier.
- Exciting effects can be achieved by mixing any two or more mediums together, a technique known as **mixed media.** Laying down collage into rough shapes can define the structure for a subsequent line drawing to create a dynamic and unusual image.

1.25 Water-based pastels.

1.26 Oil bars.

Paper

A good supplier will offer a broad range of papers, including smooth and textured surfaces in a variety of whites, tints and colours. There are some reasonably priced Indian handmade papers on the market, with decorative additives such as algae, hair and tea; these can be purchased by the sheet or as sketchbooks.

However, you don't have to spend a fortune on paper, as many interesting examples can be collected for next to nothing, or even for

*1.27 Jane Stobart, drawing with **ink** on handmade **Khadi paper**.*

free. Large Manila envelopes are good to draw on, as is brown cardboard from large packing boxes, lining paper (from DIY stores), large sheets of brown wrapping paper, mid-tone sugar papers, white cartridge with a pre-laid wash of colour, or anything else you come across that is plain or subtly decorative.

Cartridge, tracing, brown wrapping and coloured papers can all be bought in rolls, a cheaper alternative to trimmed sheets; these offer the possibility of panoramic or odd-sized drawings, an alternative to the standard 'A' proportions.

Sennelier have developed a paper specifically for chalk-pastel drawings which has a slight texture and a coating designed to cut down on the amount of 'fixing' that is usually required. This paper is available in a heavy weight – 300 gsm (see below).

Paper 'weights'

The weight of paper affects the thickness of the sheet, described as 'gsm' (grams per square metre). Cartridge paper is usually 90 to 130 gsm, but can also be obtained in the heavier weight of 300 gsm from some suppliers. Paper of between 200 and 300 gsm is recommended for drawings carried out in a wet medium.

Paper terminology

Paper surfaces fall into three main types, which indicate their surface quality:

* '**HP**' stands for 'hot press' and is the smoothest of paper.
* '**NOT**' is slightly textured.
* '**Rough**', as the term implies, is the least smooth of the three. Some paper is available in 'extra rough' surface.

Additional terms indicate a paper's other characteristics:
* '**Acid-free**' denotes the absence of any acid content in the paper. These papers are likely to be made from rag (cotton) pulp.
* **Neutral pH** refers to paper in which the acid content has been neutralised; it will avoid yellowing or other signs of deterioration over time. Acidity is the product of non-neutralised wood pulp in paper.
* '**h/m**' indicates that the paper is handmade; this will have a 'deckle' (untrimmed) edge on all four sides (see image above).
* '**m/m**' indicates a paper that has been machine-made or mould-made. Some mould-made papers will also have deckle edges; ultimately, the price per sheet will indicate the difference between a machine-made and a handmade paper.
* '**Sized**' papers have a thin liquid glue added to the wet pulp; this is known internal size. These papers can be soaked for stretching (see Chapter 10) without falling apart. Papers suitable for water-colour painting have an additional 'surface' size that prevents the paint from spreading, or 'feathering', as it is known. Only a few papers are completely unsized; these are known as 'waterleaf'.

1.28 Three types of paper, distinguishable by their edges: Ingre paper, with a trimmed edge; Somerset, a machine-made paper (m/m) with a deckle edge; black Khadi, with the edge typical of a handmade paper (h/m).

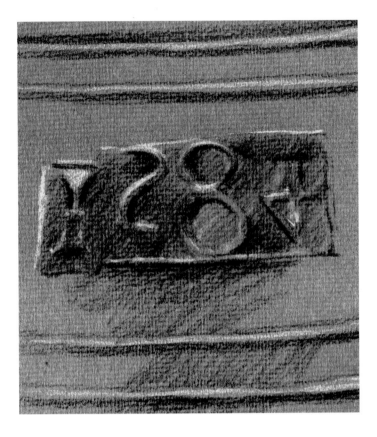

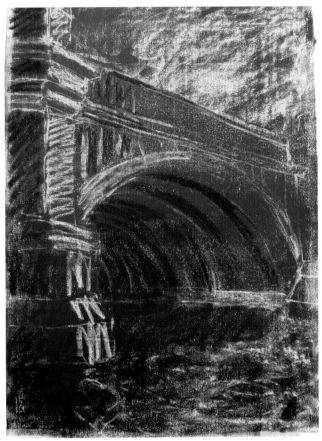

1.29 ABOVE Jane Stobart, 1584, Bell Inscription, *charcoal and chalk on mid-tone Ingre paper, 11.5 x 9 cm (4¹/₂ x 3¹/₂ in.).*

1.30 RIGHT Jane Stobart, Blackfriars Bridge, *drawn in black Conté and white chalk pastel onto an area of rolled black printmaking ink on 'greyboard', A1 (840 x 594 mm).*

Working on coloured or tinted paper

Paper whites can be described in terms such as 'soft white', 'radiant white' or 'off-white'. The choice of either a warm or a cold white will affect your drawing in the subtlest of ways. Working with a mid-tone paper, such as grey sugar paper (cheap quality but with a wide range of colours and mid-tones) or brown wrapping paper, will enable you to work up to white and down to black, rather than always starting with white, as you would with cartridge paper.

See Chapter 10 for advice on how to make your own sketchbooks from a range of unusual papers.

Buying wholesale

This will certainly offer the best deal, considerably reducing the price per sheet. However, wholesalers will insist upon a minimum price per order. If you can make an order for the same paper (rather than a mixed batch) with friends or colleagues, it is worth doing. (See list of wholesale paper merchants in the Suppliers appendix on p. 126.)

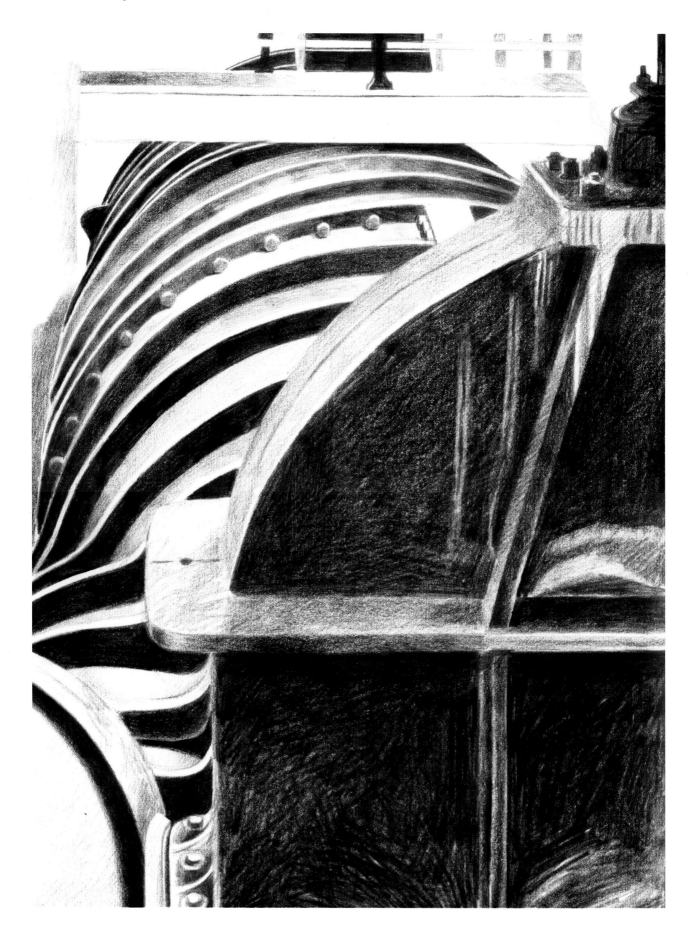

LINE, TONE, COLOUR

In this chapter we look at approaches to making drawings categorised by line, tone and colour. Often a subject will suggest an approach. A dominant light source and strong shadows may best be answered by a tonal drawing, while the challenge of depicting something on the move may prompt an animated line drawing. Profoundly beautiful or unusual colour in a subject will no doubt cry out for some kind of colour medium and perhaps suggest a specific approach, such as vigorous oil-pastel marks or soft, hazy chalk pastel.

Line drawing

This has been described as the purest form of drawing. Line is incredibly versatile, offering the potential for delicate lacy drawings, strong and expressive marks, fluid movement or intense detail. Line can

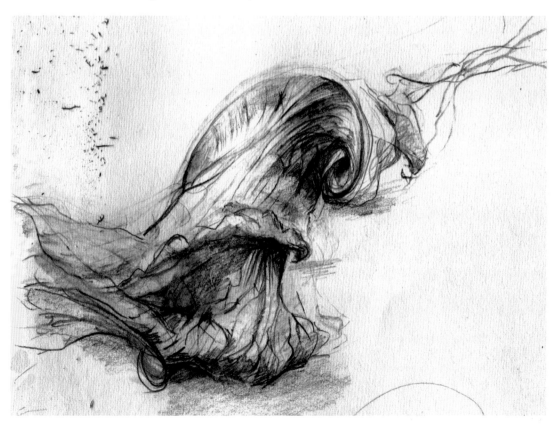

2.1 OPPOSITE *Jane Stobart*, Abbey Mills Pumping Station, *Conté pencil drawing, A3 (420 x 297 mm).*

2.2 Jackie Newell, Leaf Study, *delicate pencil line, 12 x 12 cm (4³/₄ x 4³/₄ in.).*

2.3 LEFT *Martin Barrett,* Tip Top, *detail of a larger drawing, 1,250 x 1,500 cm (41 ft 8 in. x 50 ft), made with pen and ink on paper. It deals with 'the ubiquitous nature of litter and detritus in the most remote landscapes'. This is one of a series of very large drawings exploring environmental and landscape issues which have been hugely influenced and inspired by Martin's mountaineering experiences, including expeditions to the Alps, the USA, and recently to Mt Kilimanjaro, Africa's highest peak.*

2.4 RIGHT
Margaret Steiner,
St Mary-le-Strand,
London, *ballpoint pen,*
A5 *(210 x 148 mm).*

respond to gesture or lay structure bare, stripping down form to its very essence. Working in line will justify a lengthy drawing time or, just as appropriately, it can be used as a kind of shorthand, offering a rapid and economical way of documenting a subject or an idea in a sketchbook. The choice and scale of the medium will have a big part to play in the quality of a line drawing.

Types of line

Anyone familiar with the drawings of sculptor Henry Moore will recognise his concern to eke out the form of his subjects, a process he carried out in a searching line. Compare this approach to the fluid drawings that Auguste Rodin made of his life models as they moved around his studio. His slight, sensitive pencil lines responded to the moving contours, with delicate washes of colour to suggest volume. These drawings demonstrate completely different objectives for line drawings.

2.5 *Jane Stobart*, British Museum
*Study, brown-black pencil, A4 (297 x
210 mm).*

'Tonal' line

Line can also be used to emphasise specific parts of a drawing, giving
prominence to certain objects or suggesting the spatial aspects of a
subject. In a medium such as charcoal, with all of its tonal potential,
line can be used assertively or tentatively within the same drawing.
An illusion of depth can be created by using stronger, blacker or
thicker lines to bring specific parts forward. A 'sliding scale' of tonal
strengths as the objects recede will suggest depth and location in
space. A line drawing without a variety of considered weights,
strengths and emphases will offer the opposite result. Martin Barrett's
massive drawings (e.g. fig. 2.3, opposite), carried out in a delicate pen-
and-ink line, accentuate the rhythm of complex rock and rope
structures without a variation of line strength.

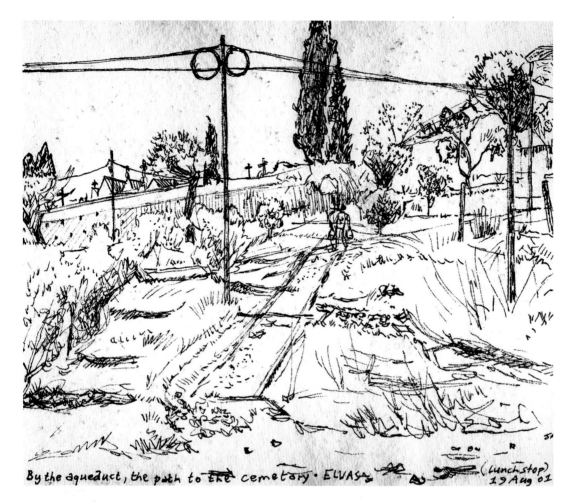

By the aqueduct, the path to the cemetery • ELVAS. (lunch stop) 19 Aug 01

Essential clues

It is an interesting exercise to see just how little you need to include to represent a subject. If your drawing is accurately proportioned, the eye will connect the depicted parts by filling in the missing information.

A moving line

To attempt a drawing that expresses movement will test your observational skills to the very limit. Never underestimate the importance of time spent looking hard in an attempt to understand the rhythm and pattern of movement and the tension and dynamics therein; relying on memory alone, you can then draw with an understanding of what you have observed.

In a subject on the move, such as an animal or bird, you might consider a multi-line approach to suggest the pattern of movement. Try a fluid line without taking the pencil from the paper, in an attempt to respond to the pace of the movement.

2.6 Jacqueline Atkinson, By the Aqueduct, *technical pen and Chinese ink, 11.6 x 14.5 cm (4¹/₂ x 5³/₄ in.). The mood and ambience of a particular time and place: a dusty refuge in the shadow of a massive Roman aqueduct on a torrid Sunday afternoon in Portugal.*

2.7 Linda Wu, David Digging *(detail), charcoal and wash (original drawing A1 [840 x 594 mm]).*

2.8 Robert Bramich, Dog, *black pencil drawing, 9.5 x 15 cm (3¾ x 6 in.).*

Ideas for working with line

- Look for contours in your subject. The human head, a sleeping pet or a rocky vista will make excellent subjects for a line drawing that strives to explain mass and volume. Use a medium that will offer a tonal range of line, such as charcoal.

- I recently saw some incredible drawings by painter Augustus John in a temporary exhibition at the Fitzwilliam Museum in Cambridge, UK. All the drawings were of friends and family. He worked rapidly and loosely from the neck down, but emphasised the face in each drawing with intense linear detail. The two approaches worked wonderfully to complement each other. David Hockney often adopts a similar approach in his drawings and etchings.

- Use tonal line to describe the spatial aspects of a subject, e.g. darker lines will come forward and paler lines will recede. Make a measured drawing of an internal space, such as a view through a door in your home to another door and beyond; here is a subject with very clear positions in space. A church interior will offer you the opportunity of emphasising vastness by using strong, medium and pale lines for the farthest details.

- Work with a black line (charcoal or Conté) and white line (chalk or pastel) onto a mid-tone sugar paper or Ingre paper, to describe light and dark with line alone. Alternatively, work with orange and blue pastel lines, to communicate light (with warm orange) and shadow (with the coolness of blue).

Tonal drawing

To achieve solidity in a drawing, or to describe the effect of light hitting an object, a tonal approach may be considered, to which certain materials lend themselves superbly. A thick graphite stick, fat pastels, Conté or charcoal will enable you to put down tonal values quickly and make adjustments as the drawing develops; if you are using charcoal, a putty rubber will allow you to reclaim highlights and lighten areas that have become too dark. As an alternative to continuous (solid) tone, soft pencil or graphite stick can be used for building up scribbly tonal areas, using a mesh of lines. Alternatively, a wash of mid-tone paint or ink on a line drawing is a good way of making quick tonal studies.

Using tone effectively

Students adopting soft pencils to carry out tonal drawings often resort to smudging with fingers to create sleek effects. Experienced artists and teachers of drawing will tend to discourage this superficial slickness, instead encouraging students to be lead by the true qualities of a drawing medium and the marks that they make naturally on a specific paper surface. Charcoal is a highly flexible medium which lends itself better to being smudged, with tissue, cotton wool, worked into with a putty rubber or with your fingers (see Paul Emsley's drawing, fig. 8.13 on p. 108). Blending sticks can also be obtained for the sole purpose of smudging and removing or lightening areas of tone from charcoal, Conté and chalk pastels (see Judy Groves's drawing, fig. 2.12. p.37).

 Apart from indicating a light source and the resulting shadows, tone offers atmospheric possibilities for a subject such as the interior of a church, a particular time of day or certain weather conditions (see Dennis Creffield's cathedral drawings in on pp.100-101). Tone will emphasise weight or volume in an object or suggest mass in the human form.

2.9 Simon Fitzgerald, Study of Rodin's 'The Cathedral', *41 x 23.5 cm (16 x 9¼ in.).*

Tonal 'perspective'

As with a tonal line drawing, stronger, darker tonal areas will leap forward, while paler tones will tend to recede, offering your drawing an illusion of depth. In a drawing that is attempting to create distance between objects, the scale of the mark you make will be an important consideration. This approach to a drawing may require you to ignore the literal strength of tone or colour and impose a 'sliding scale' of tonal strengths in order to suggest distance.

A substitute for colour?

Tonal values in a drawing are often viewed as a substitute for colour – e.g. a woman's purple dress may be translated into a strong, dark grey, etc. However, guard against an over-literal translation – yellow as a pale tone, orange a slightly darker tone, etc. – as this has nothing to do with the structure of your subject. Draw only what is essential to the form or to give an indication of light source and shadows. When using cartridge paper, you may consider designating the colour of the paper to be the lightest areas of your subject. Drawing 2.11 (overleaf) is made on Ingre paper, which offers a mid-tonal starting point. Onto this base you can work backward and forward to indicate light and dark, taking the middle tones as read.

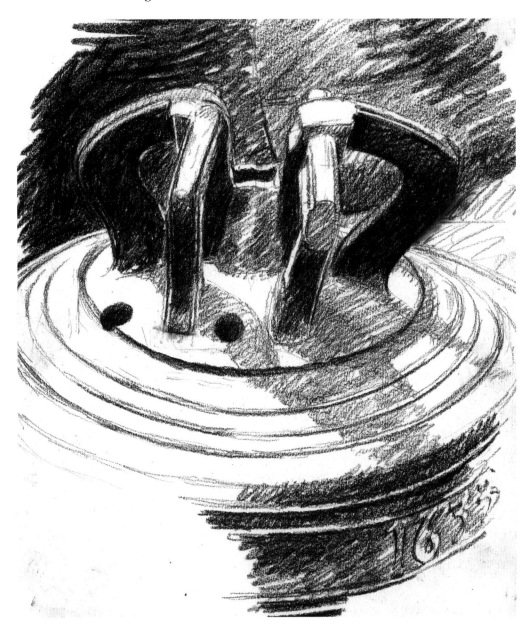

2.10 Jane Stobart, Old Bell, *charcoal, 42 x 29.7 cm (16¹/₂ x 9¹/₄ in.).*

Seurat is the master of the tonal drawing executed without any lines at all; he drew on textured Ingre paper using soft Conté, a combination that lends itself to wonderfully atmospheric, textural drawings. Soft tonal media such as Conté and charcoal will require fixing in order to stabilise your drawing; fixative can be applied while the drawing is being made as well as when it's finished. (See Chapter 1, p. 16 and Chapter 10 for more information on types of fixative, as well as health and safety aspects when using it.)

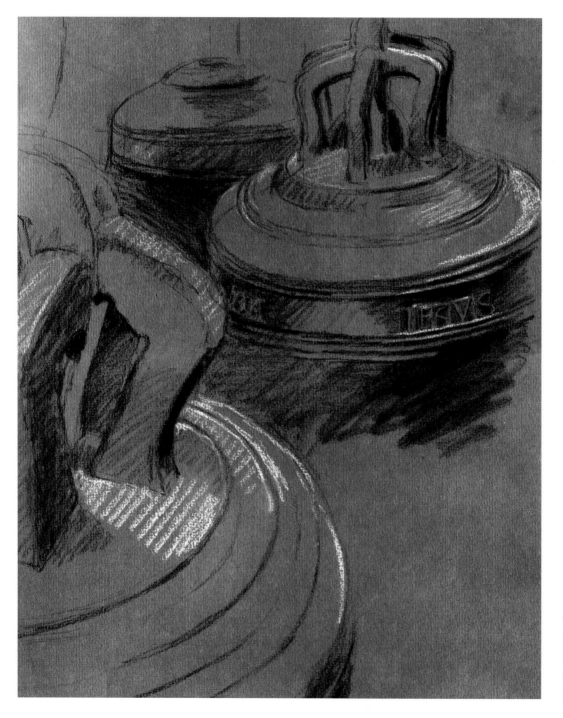

2.11 Jane Stobart, 3 Bells, charcoal and chalk on mid-tone Ingre paper, 42 x 29.7 cm (16½ x 9¼ in.).

2.12 Judy Groves, Twin Faces with Flowers *(detail), coloured pastel on lining paper, 48 x 38 cm (19 x 15 in.).*

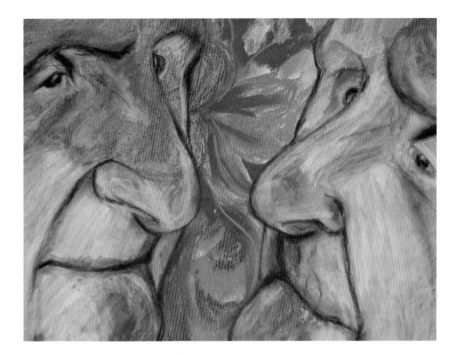

Ideas for working with tone

* Looking at sculptor Antony Gormley's silhouette drawings depicting his own body inspired me to carry out a series of similar images in a sketchbook, using studies of bell founders (see fig. 1.16, p. 18). As long as the shape and/or gesture are interesting, the loss of detail does not prevent strangely expressive drawings from emerging.
* A solid area of mid-tone laid down with charcoal gives an atmospheric base for additive and subtractive drawing. Introduce the lighter shapes and whites with the aid of a putty rubber or chalk, while drawing in darker shapes with black Conté.
* Limit your tonal range to just white, black and mid-tone on a tinted paper.
* Gesture and movement can be expressed in quick tonal drawings. The side of a short, fat piece of charcoal, Conté or graphite stick will offer instant tonal strokes for responsive, gestural drawings.

Drawing in colour

A colour drawing can be approached in so many ways. Colour can be applied in the form of a transparent wash onto a line drawing or conceived as solid, opaque areas using a medium such as oil pastel. As with tonal drawing, it is advisable to get your colours blocked in rapidly, as every area that you observe will be influenced and altered

2.13 Jane Stobart, Bells, *oil pastel, A3 (420 x 297 mm).*

by the colours adjacent to it. Use a drawing medium that will allow you to make adjustments as the drawing develops, such as oil pastels or good-quality chalk pastels.

A little understanding about the way colour works is essential to avoid adding naive and unrealistic colour to a drawing. Most of what we see is subject to light and shade, which to some degree will alter the apparent hue of any colour. Knowledge of how to dull down colour, or to 'neutralise' it, is therefore essential.

Colour mixing

Visualise a basic colour wheel by bringing to mind the three primary colours in the form of a triangle. Next add the secondary colours; these are the result of mixing the two bracketing primaries – e.g. blue and red make violet.

2.14 The basic colour wheel in oil pastels, in which the three primary colours are cadmium red, cadmium yellow and ultramarine. The secondary colours – orange, green and violet – are the result of mixing each of the two bracketing primary colours.

If you remember nothing else about colour theory, recalling this simple diagram will offer the key to creating realism and avoiding artificial brightness in a colour drawing or a painting. It will also save you the expensive outlay of buying obscure, neutral colours, and arm you with the knowledge to create them yourself.

2.15 Diagram of a neutral band in chalk pastel. Mixing two complementary colours together will eventually create a neutral colour.

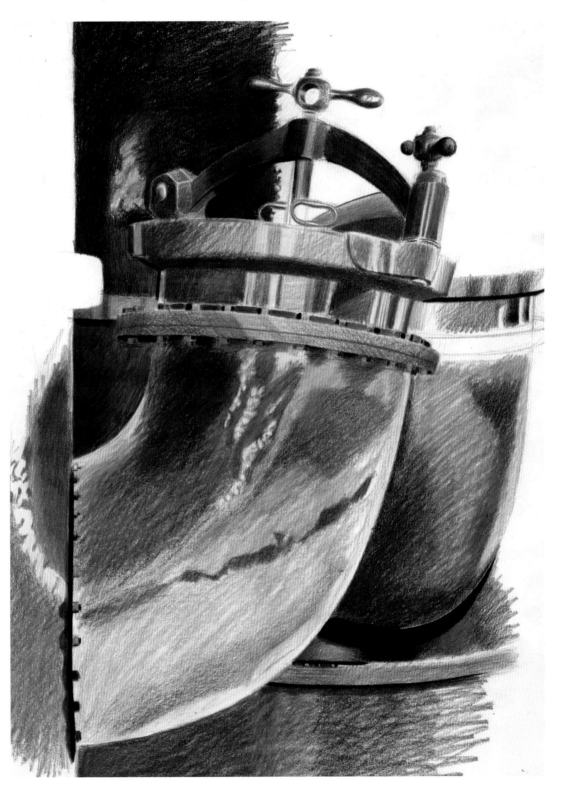

2.16 Jane Stobart, Gin Distillery, coloured pencil, A2 (594 x 420 mm).

Dulling colour down (neutralising)

The colours that lie opposite each other on the simple colour wheel (fig. 2.14, p. 38) – i.e. red/green, blue/orange, yellow/violet – are the key to creating the subtleties that can make colours appear more natural. These pairs are called complementary colours ('complementary' meaning 'to complete'). When mixed together they create a neutral colour that is unrecognisable as either of its constituent parts.

However, before arriving at an absolute neutral, a pure colour like orange will be dulled by the addition of a small amount of blue, its complementary colour, and vice versa. The other two complementary pairs (yellow/violet and red/green) will have a similar effect when mixed – e.g. yellow is made less brilliant (dirtier) by the addition of a small amount of violet, etc. See fig. 2.15 on p. 39.

What colour is shadow?

Take an object such as an orange and place it onto a piece of white paper. The part of this sphere furthest from the light source will be in shade, making it a darker orange colour. If you are drawing in pastels, this effect can be created by introducing a mid-blue (the complementary colour of orange) and working the two colours together on the side in shadow, finishing with orange so as not to lose the predominant colour. Where the fruit casts a shadow onto the paper, you will observe that there is a coolness to the colour. Look to blue/violet with lots of white, and if that looks too bright, work in some mid-yellow (the complementary colour of blue-violet) to dull the shadow.

'Red' is a relative term

Many colours can be referred to as 'red': some are warm, being nearer to orange, such as 'vermilion'; while other reds are closer to violet and altogether cooler, such as alizarin crimson. Cadmium red is generally felt to be the truest primary red, but even this can alter slightly from one paint manufacturer to another.

Yellow also offers a vast array of variables. Lemon yellow is an 'acid' yellow and will create a fresh green when mixed with cobalt; while cadmium yellow deep is distinctly warmer, and creates a gorgeous orange when mixed with vermilion.

Cobalt or cerulean are both blues that are closer to green; while French ultramarine is cooler, and will result in an excellent violet when mixed with the blue-red alizarin crimson.

2.17 Jane Stobart, Bell Cases, *oil pastel, A3 (420 x 297 mm).*

2.18 Creating a black with pure colour, using chalk pastels.

Creating black

Using a manufactured black has a tendency to kill your colour values, and for this reason many painters steer well clear of it. However, if you have the need for black, try mixing it from pure colour. Combining a very dark blue, such as Prussian blue, and the darkest brown will establish an immediate dark without the deadness of a commercially manufactured black.

Emphasis with colour

In the making of a drawing that relies on the appearance of a spatial distance (near to far), strength of colour will clearly be important. Also, observe that bright warm colour, such as red, orange and certain yellows, will have the tendency to come to the foreground of a drawing, while violet-blues give the appearance of receding into the background. This is essential knowledge when dealing with big subjects such as landscape. In rural areas where the air is cleaner, colour in the landscape is more intense, and it is easier to observe how distant features recede into distinct violet-blues.

2.19 RIGHT Jane Stobart,
Southwark Bridge Sunset, *chalk pastel on card, A1 (840 x 594 mm).*

2.20 OVERLEAF Arthur Lockwood,
Awaiting Demolition, Coombs Wood Works, *Rotring pen drawing with watercolour on Saunders Waterford paper, 52.5 x 97.5 cm (20³/₄ x 38¹/₂ in.). Arthur Lockwood records the urban decay of industrial Birmingham and the Black Country with an amazing eye for colour. He works on the spot, sitting in factories or streets or, if the weather is bad, in his car.*

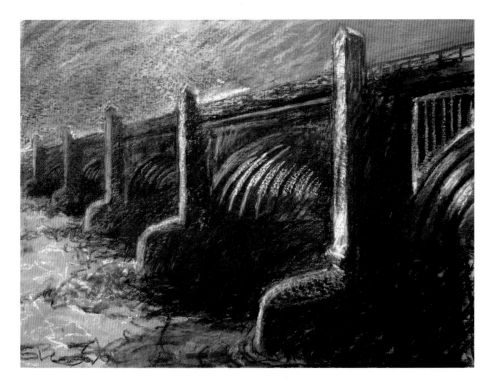

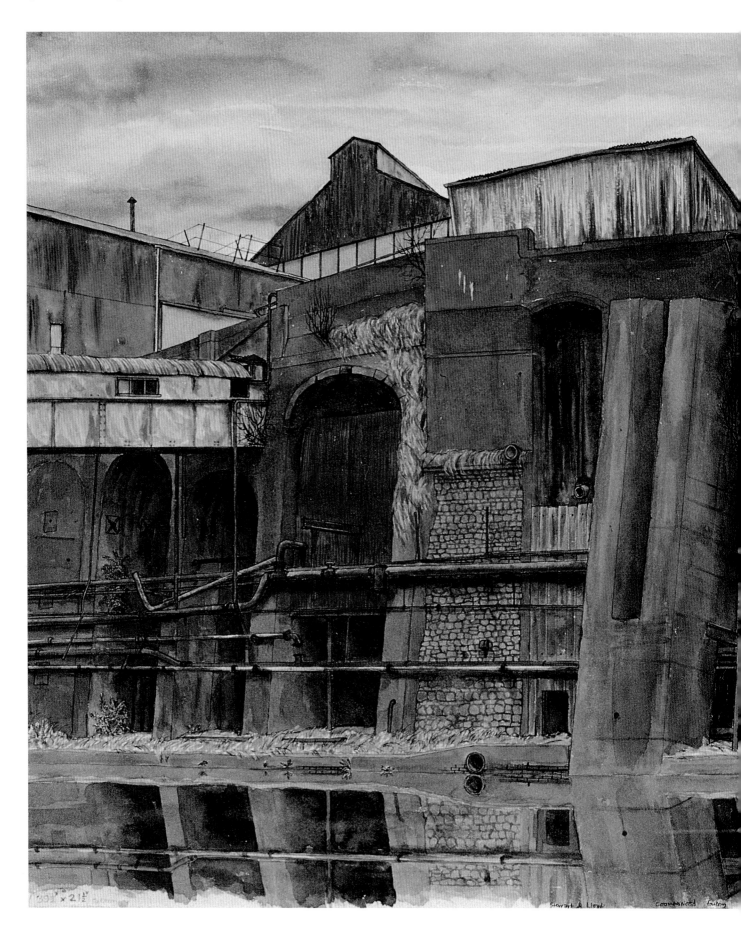

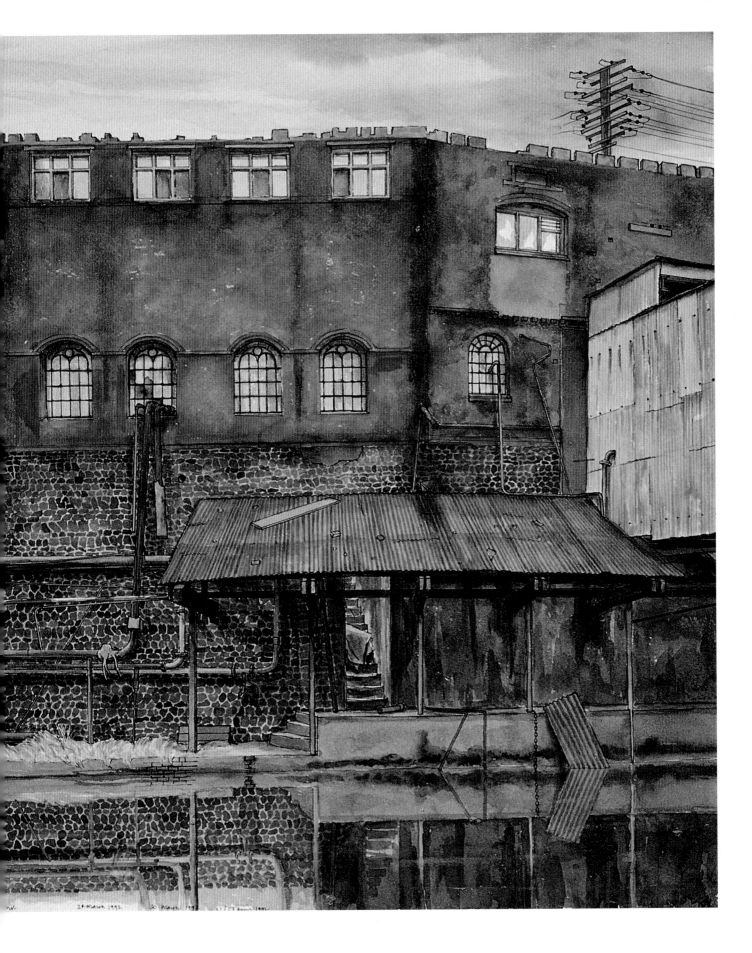

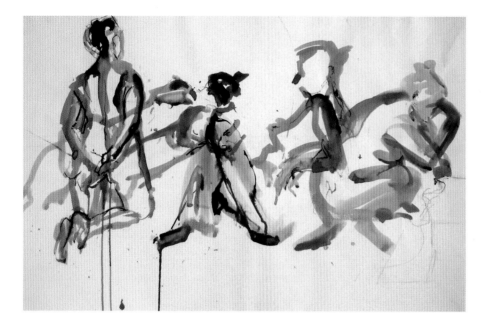

2.21 Linda Wu, rapid life drawings with a suggestion of colour, made with gouache paints, A1 (840 x 594 mm).

Mark-making

The scale of the marks you make in the application of colour (or tone) will also have a major part to play in creating the appearance of distance. Expressive, active mark-making will bring an object or area into the foreground, while softer, less dynamic application of colour will assist in giving the illusion of distance.

Ideas for working with colour

- Generalised colour can be added to a line drawing with diluted ink or watercolour washes, a quick and expressive way of suggesting colour without the colour dominating.
- If you are confident enough, try laying the washes of colour onto the paper first, and then making a line drawing on top, to achieve a looser drawing.
- In a drawing of solid, opaque colour, apply daubs without blending them together, using oil or chalk pastel, or paint. The colours you apply in close proximity to each other will blend visually from a distance, as Seurat's do. This will challenge your analysis of colours and the changes that occur from the lightest parts of an object through to areas of shadow.
- Working in line with colour can make for lively drawings. Ignoring the literal colour, overlap quick drawings of a moving subject on the same sheet of paper, each in a separate colour so that each drawing can be read individually.

Chapter 3 IDEAS AND INTENTIONS

3.1 Dr Young-Gil Kim (Korea) White on White, *gesso and emulsion on board, AO (1188 x 840 mm). This work is a low-relief coloured entirely in white, where shapes and lines are defined by shadows; it pushes the boundaries of what a drawing can be.*

So far we have looked at how the choice of material and the marks that you make will have a massive influence upon a drawing. Chapter 2 considered some approaches to image-making. Now, focusing on the purpose and intentions behind a drawing, we will consider a range of conceptual possibilities.

There may be many reasons for making a drawing. The same subject will inspire people in quite different ways. Your intentions might range from practical research for the purpose of gathering visual information to use or develop at a later date, to the desire to express something beautiful, a drawing executed for purely aesthetic reasons. Sometimes a subject will suggest or inspire a drawing, but in general artists will seek an area that is of particular interest to them. This chapter offers a few ideas from the vast range of possibilities.

A response to the subject

Decide what you want from your drawing. As this will be a two-dimensional visual statement about a selected part of reality, you can only hope to describe or express an aspect of what you see – in other words, you can't achieve everything, so be selective in your intentions.

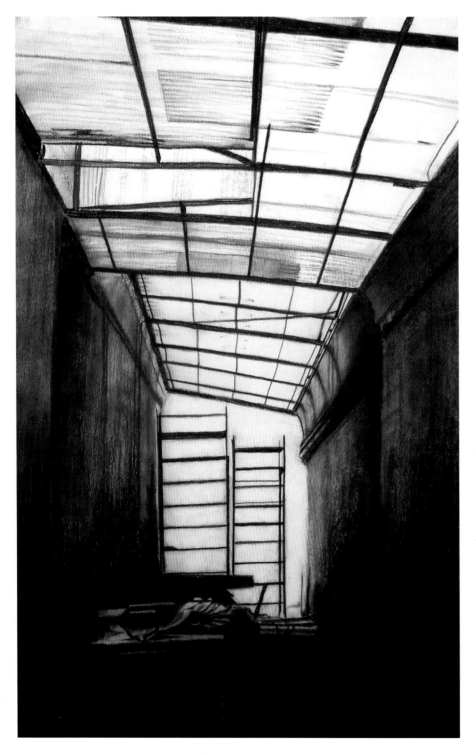

3.2 Kathy White, Ladders, *charcoal and Conté crayon, 84 x 53 cm (33 x 21 in.), a drawing from a series entitled* Borderlands. *Student Kathy White made this drawing (and* Hopper, *see fig. 3.11, p.53) as part of a project to illustrate the feeling of industry at rest by portraying industrial estates at the weekend when the workers have gone home and the factories are quiet. 'I spent many weekends out in the local industrial areas taking photographs as research for my project. I prefer to draw from life but I think that the drawings work well and have captured the stillness I wished to portray.'*

3.3 Linda Wu, Red Man, *chalk pastel on handmade paper, A1 (840 x 594 mm). This life drawing in chalk pastel was made in response to a photographic image of foliage that had been projected onto the life model.*

You may consider:

- Accurate representation or '**photorealism**' in full tone or colour – as in Kathy White's drawings (figs 3.2 & 3.11) or Paul Emsley's (figs 8.13 & 8.14 pp.108-9). Intense observation and a long period of time will be needed for this type of drawing. Working slowly, with intimate observation, build up tone or colour gradually.

- An exploration and **search for form**, just as a sculptor might view the world. Work with a searching line to eke out the contours of the subject, letting your line move freely across the surface, ignoring light and shadow, concentrating only on mass. Ballpoint pen or pencil is good for this type of drawing; add wax and wash to suggest solidity of form.

- There is great potential for experimentation in the attempt to express **movement**. Drawings of athletes or dancers or animals will offer an interesting set of problems. Linda Wu's drawing (fig. 3.4, overleaf) overlaps images across the page as the subject moves, helping to communicate the sense of a man's presence as he moves. This is a good way to suggest the different phases of action and avoid a static image. Each additional drawing can be incomplete – perhaps just a single directional line or brush stroke – helping to convey the passing of time. An understanding of what you are seeing will involve intense observation of the rhythm of movement.

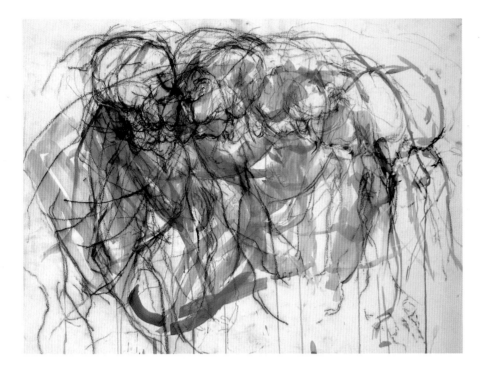

3.4 *Linda Wu,* David Digging, *charcoal and watercolour wash, A1 (840 x 594 mm). This expressive drawing captures the movement of someone digging a garden.*

- I saw an inspiring work of art recently, made by American artist Lee Krasner from some of her **old drawings cut and pasted** onto canvas. They had been boldly chopped and juxtaposed to create directional lines and a strong sense of movement, forming a new, recycled image. Here is an example of an artist finding new things to say with her previous work.

- Try a radical scale change: a series of **miniatures** (A6 or smaller) of a vast subject, or perhaps some **A0 drawings** (1188 x 840 mm) depicting tiny, intimate details of a subject on a grand scale.

- A drawing that focuses on **rhythmical structure** and ignores tone and colour – e.g. a line drawing of natural objects, skeletons, industrial subjects, machine parts, or complex architectural subjects. A searching, lacy line that picks up on pattern, repetition or rhythmical shapes within a subject.

- An expression of **striking colour** without the emphasis on detail in a medium such as chalk pastel – inspired by a jostling market, a landscape, seascape, exotic birds or the beautiful colours of a dying leaf. A series of time-lapse drawings, dealing with decay or weather changes.

- **Quick visual 'notes'** or **long accurate studies**, to be used as reference for further work. Taking the idea of the thematic sketchbook a step further, try producing a body of drawings that focus on one particular subject which you draw hourly or daily more fully to explore its possibilities.

- A series of long or short **self-portraits**. Never do just one drawing of a subject when you can do thirty. Rembrandt did a series of

3.5 OPPOSITE *Arthur Lockwood,* Coventry Colliery, No.1 Winding Engine, *pen and watercolour, 66 x 48 cm (26 x 19 in.). Artist Arthur Lockwood has single-handedly documented a large area of industrial Birmingham (UK) with his pen drawings, to which he adds watercolour. Many of the locations he has drawn are now either derelict or have been completely demolished; his dedication has produced a unique legacy of the industrial past (see also fig. 2.20, p. 42–43).*

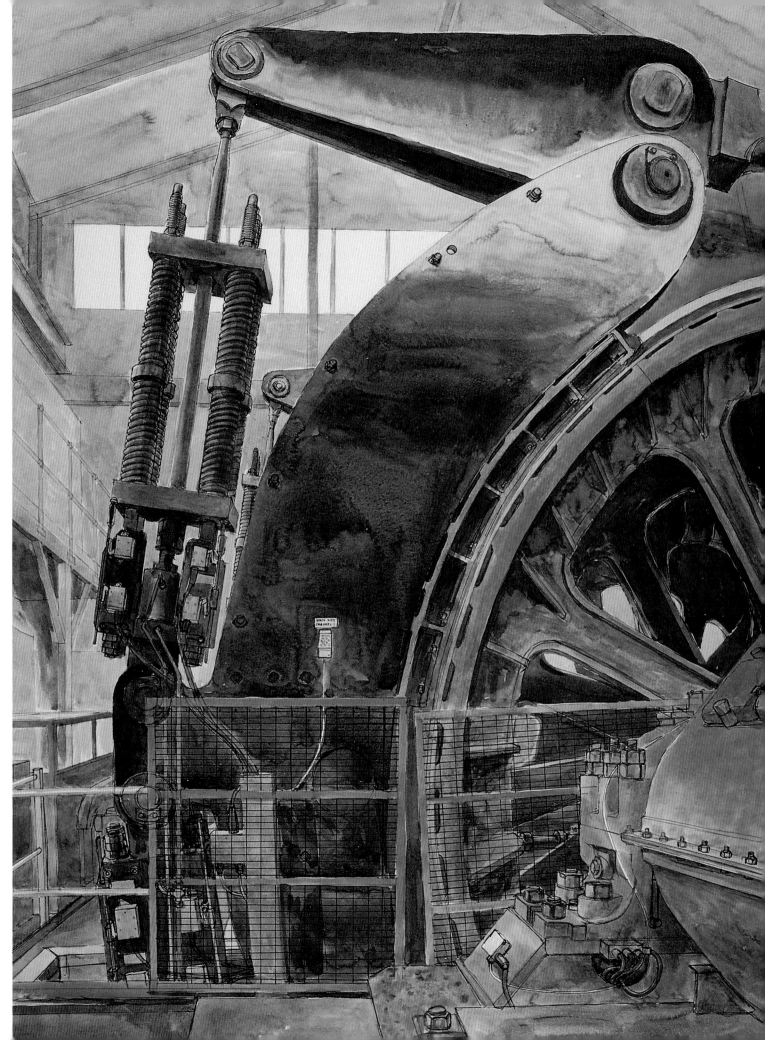

self-portraits as tiny etchings, in which he made faces of shock and surprise.

- **Intense shadow**, where detail and form are subdued or lost entirely. With a putty rubber, work back from an area of solid charcoal to carve out details or highlights that suggest form without revealing everything.

- The **fluidity and rhythm** of water – at the seashore, in a river, in the swimming baths, from a fountain or even in the different volumes of water gushing from a tap. The movement of water can never be pinned down, so there is plenty of potential here for experimentation with line or with mixed media.

- Look up! Draw the **tops of buildings** from your viewpoint on the ground.

- Ignore all else but **silhouette** so as to emphasise gesture, working with the negative or positive aspects of your subject.

- Accentuate **atmosphere** in the subject you are drawing, closing your mind to specific details. Study Dennis Creffield's large charcoal cathedral drawings (see figs 8.4 & 8.5, pp.100-101), in which he sometimes works across structures with swathes of charcoal tone.

3.6 Jackie Newell, Dying Leaf, *chalk pastel, 14.8 x 21 cm (5¾ x 8¼ in.). Drawing from a sketchbook, capturing the phenomenal colours of a dying leaf.*

3.7 Jane Stobart, Millennium Bridge, *ink wash, 11.5 x 10 cm (4½ x 4 in.).*

3.8 RIGHT Jane Stobart, Bell Cases, *candle, chinagraph pencil, ink wash, A4 (297 x 210 mm). One of a series of drawings focusing upon the abstract shapes of industrial objects, without revealing their identities.*

- Whistler made many **images of the night**, initially committing to memory what he saw in his night wanderings – to be recreated later in his studio.

Drawing from memory

Increasingly now I draw from memory, which is an interesting and somewhat liberating thing to try. It is arguable that all drawing is done this way, as even with the most accurate of drawing aspirations your eyes must become averted from the subject in order to focus at regular intervals on the drawing paper. Memory therefore inevitably plays a key role.

3.9 LEFT Linda Wu, Four Life Studies, *charcoal and paint on brown wrapping paper, A1 (840 x 594 mm). A sheet of life drawings of poses lasting for a few seconds only, where a rapid, intuitive response is vital.*

3.10 ABOVE Jane Stobart, Silhouette of Bell Founder, *diluted ink, A4 (297 x 210 mm).*

I have found that drawing a particular subject from observation over a long period of time has enhanced my knowledge and understanding of shape and construction. Drawing from memory helps me to avoid a tendency to be too literal, and taps into the unconscious.

There are several well-known drawing exercises, practised since the Renaissance, that are designed to sharpen the skills of observation:

- Carry out several minutes of intense scrutiny without drawing. Turning from the subject, now draw what you remember.
- The visual experience of being in a night-time location, without the aid of a torch to draw by, can be remembered and visualised later. Whistler often worked in this way, as already mentioned.

Challenge your perception

Drawing tutors will often warn against adopting a 'style' or 'technique' which can act as a creative straightjacket. To impose such narrow criteria on your drawing will hinder its (and your) potential.

Certain theoretical books discuss the ways in which artists can challenge their own perception and skills by adopting methods which 'frustrate' their facility. The following may seem a little bizarre and unconventional to some students of drawing, but for those interested in developing their response to a subject and sharpening their drawing perception, these are valuable physical and conceptual exercises:

- Tying charcoal to the end of a long stick to lessen control; this will force you to find an unfamiliar way of working, and will result in a very different sort of drawing.
- Drawing without removing the pencil from the paper, by moving around and across the planes of the subject in a search for form.

3.11 Kathy White, Hopper, *charcoal and Conté crayon, 84 x 60 cm (33 x 23½ in.).*

3.12 LEFT *Dr Young-Gil Kim,* Taxonomical Drawing 1 *(2004) (detail), pencil on paper, 60 x 84 cm (23½ x 33 in.). Korean artist Young-Gil Kim made a series of drawings of his installation of clay shapes. This detail is from the first drawing, executed with a delicate pencil line.*

- Drawing with the 'other' (non-drawing) hand is also an interesting and challenging exercise, designed to break old drawing habits and increase invention.

- Looking very hard at the subject, then drawing with your eyes shut.

- A conscious change of drawing medium, or scale of medium. Adopting a large-scale material, such as a pastel with the girth of a Cuban cigar, may feel clumsy, but it could also lead to large-scale drawings with an increased degree of economy. A finer scale of implement, such as a mapping pen and ink, may result in greater detail, causing you to look intensely at specific aspects of a subject.

- Surround yourself with all your drawing materials and 40 sheets of paper. Make 40 drawings of the same object (a rusty pair of pliers; a poppy head; a sleeping cat) in a set period of time. A two-hour non-stop drawing session will give you three minutes to carry out each drawing.

A change of scale

A conscious change of scale will also challenge your perception and skills. Shock tactics imposed by drawing tutors will sometimes take the form of handing out tiny pieces of paper for miniature studies, or communal drawings the size of a studio wall. These are valuable exercises in developing flexibility and inventiveness.

3.13 RIGHT *Martin Barrett, three-dimensional drawing made from cardboard, the lines defined by light, 61 cm (24 in.) long. 'This is one of a series inspired by the sort of odd buildings that crop up all over the world in remote places. These normally have nefarious Cold War connections and some have cathedral dimensions. Their functions tend to give a bleak insight into global tribalism.'*

3.14 OPPOSITE *Glenn Holman, giant Conté drawing, 244 cm (8 ft) high. 'The drawing is an extension of my interest in landscape as a subject matter, and in particular woodlands. Mimetic representation is not my intention with the work, rather an exploration of the idea of the physical and its arrangement within space, and how this can be navigated through visually, physically and metaphorically. As the drawing progressed it has taken on an architectural quality and has reference to classical church-architectural arrangement of columns and vaulting. The notion of the drawing describing a "spiritual" or meditative space was unintentional but may provide a rich source of further investigation.'*

Looking at artists' drawings

Finally, when considering your own reasons for making a drawing, looking at great work from the past can furnish you with a variety of ideas for possible conceptual approaches to every subject area imaginable. Studying drawings from Leonardo da Vinci through to contemporary artists such as Paul Noble is bound to inform your own drawing practice. Visitors to major museums can often gain access without appointment to their study rooms, where a specific artist's drawings can be requested and handled. Museums that do not offer this service will still allow you, by appointment, to go behind the scenes and view specific items from their collection. Enquire about this service at any museum.

If you can't manage a museum visit, library books or postcards are a great source of inspiration that will still offer clear a indication as to an artist's specific intentions. I have a couple of dozen postcards pinned to my studio wall at any one time, showing drawings by artists ranging across the centuries from Michelangelo to David Hockney; they are a great source of reference and inspiration.

If you haven't already done so, study a Frank Auerbach drawing or reproduction. His search for what he calls the 'decisive moment' is revealed in the obvious struggle and energy of the drawing process. Antony Gormley's silhouetted forms demonstrate a clearly different intention and idea; his drawing materials range from coffee to semen and nearly all of his work, including his sculpture, features his own body. One can also learn a great deal from studying Henry Moore's sculptural wax-and-wash drawings. His World War II commission featured a series of drawings made from acute observation, and then from the memory of the forms of the multitude of Londoners who sought refuge from the air attacks in tube stations. The rows of sleeping figures take on sculptural forms. One entire sketchbook of these 'shelter' drawings has been published as a facsimile hardback book – another valuable resource.

COMPOSITION AND DYNAMICS

4.1 OPPOSITE *Jane Stobart,* Abbey Mills Pumping Station, *charcoal drawing, A1 (840 x 594 mm). This drawing was made from a high vantage point in a large industrial building situated in East London.*

4.3 *The hole of a viewfinder should have the same dimensions as your drawing paper. This will make it possible to transfer your selected composition onto A3 (420 x 297 mm), A2 (594 x 420 mm) or A1 (840 x 594 mm) paper. The addition of half and quarter indicators will assist in the translation from view, to the drawing. Make your own from a piece of stiff paper; the hole should measure 45 x 32 mm (1¾ x 1¼ in.), which are the proportions of an 'A' sheet of whatever size. Illustration by Mustafa Sidki.*

A carefully considered composition will vastly influence the visual dynamics of a drawing. The selection and organisation of the positive and negative shapes, and their relationship within the picture area, form an invisible framework essential in creating symmetry, asymmetry, harmony, disharmony, rhythm, dominance, visual tension or a particular emphasis. Composition is a subjective issue, but the ability to orchestrate scale, shape and space to fulfil a personal objective is a necessary skill in all types of image-making.

The following points are generally agreed to be the basic rules of composition:

- Horizontal emphasis within a composition is considered to be calm, passive and pleasing to the eye – e.g. a wide-open landscape with distant hills, or the far horizon of a seascape.
- Diagonal is dynamic and will stress movement – e.g. detail of complex machine or engine parts, or a pile of tumbled bricks.
- Vertical shapes and lines make for strength and stability – e.g. the receding columns of a cathedral interior, or a mature forest.
- Symmetry is balanced and visually 'comforting', implying order.
- Asymmetrical compositions will create a visual dynamic.
- Visual rhythm (with no particular emphasis) can lead the viewer's eye around a composition.
- Overcrowding a composition will create a visual claustrophobia.
- Jagged shapes suggest tension.

Working with a viewfinder

When considering the composition of a drawing, using a viewfinder can help enormously. This is akin to looking through the lens of a camera, effectively shutting off everything but selected areas of your subject, allowing you to consider specific and selected parts of what you see.

According to the distance the viewfinder is held from the eye, a kind of zoom effect comes into play, which will assist you in making

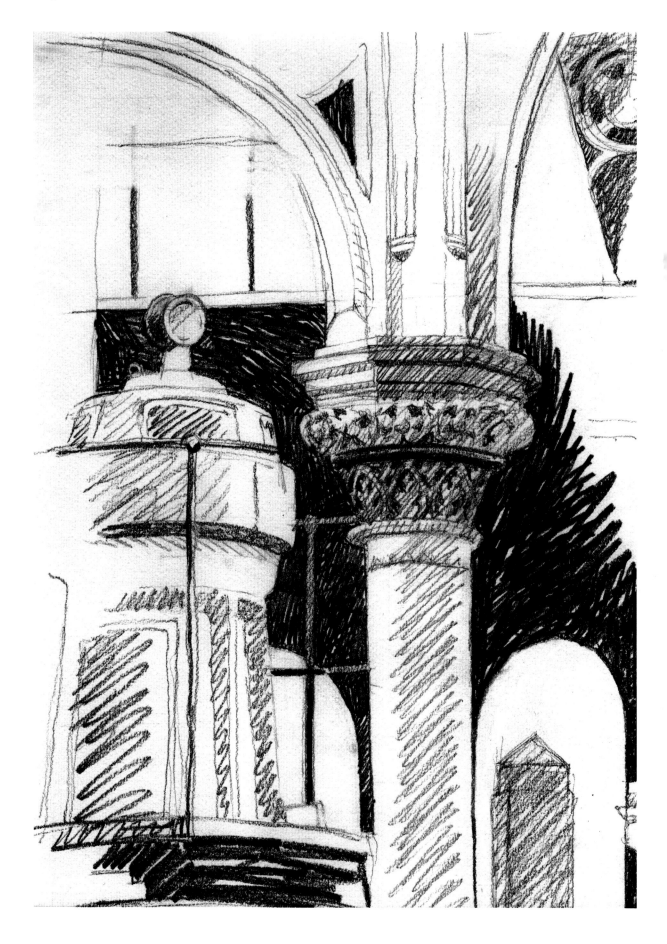

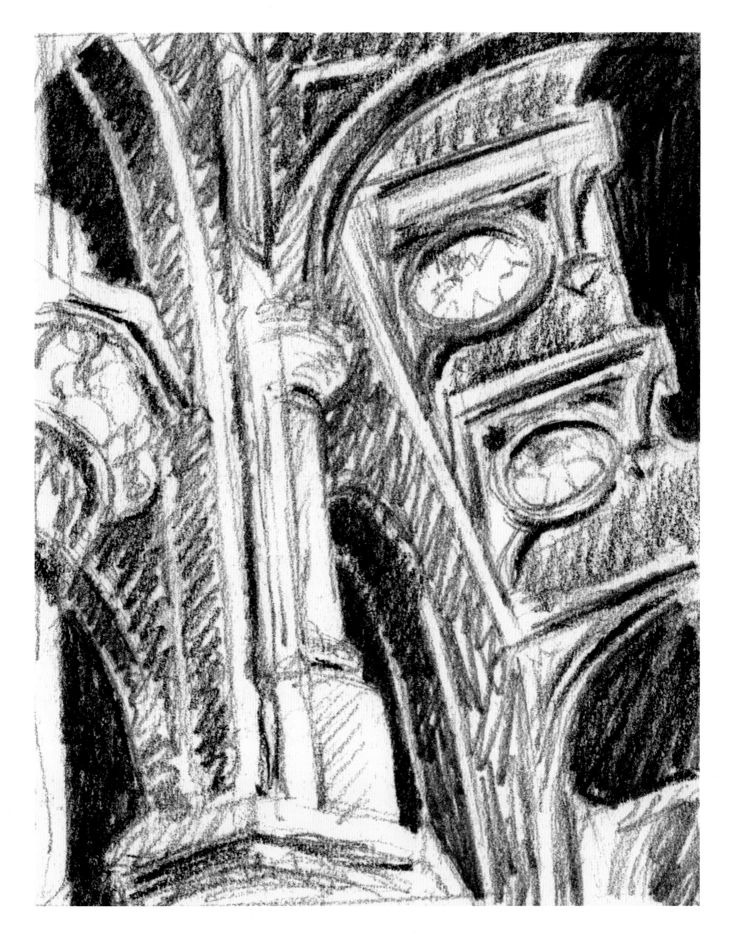

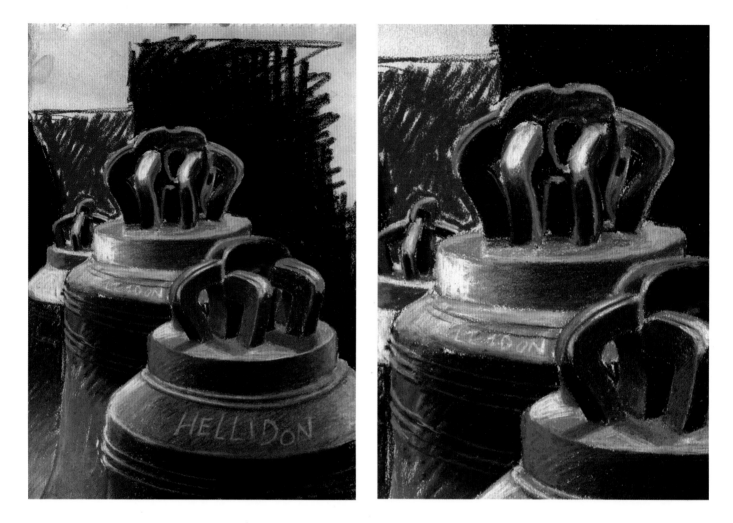

choices regarding scale. Sketching out small, quick drawings at the outset will allow you to consider several ideas before making your final decision. Pencil marks to indicate half and quarter markings around your viewfinder hole will help to assess the position of some key shapes within the composition and assist you in translating what you are seeing into a large drawing.

Considering scale

How large will your subject be, relative to the drawing paper? The scale of the depicted elements within a drawing will probably be the first thing you will need to consider. Does the subject fit comfortably into the picture plane, or will you focus on only a part of the subject, or else a tiny detail massively enlarged? Dynamic scale, i.e. objects drawn too large for their allotted space, is used to telling effect in American super-hero comic books, which perfectly illustrate the creation of a certain kind of visual dynamism. Giorgio Morandi's quiet tonal still-life paint-ings, on the other hand, demonstrate a very different compositional

4.4a, 4.4b, 4.4c & 4.4d ABOVE LEFT AND RIGHT, AND OPPOSITE LEFT AND RIGHT Jane Stobart, Bells, *Conté drawing with enlarged sections, A3 (420 x 297 mm). Take time to consider vastly different decisions about the scale of your subject, using a viewfinder for dynamic close-ups.*

4.2a & 4.2b (PREVIOUS PAGES) Jane Stobart, Two Roughs of Abbey Mills Pumping Station, *two quick drawings of the interior of the building. The first is symmetrical and balanced; the second a more dynamic scale, viewpoint and arrangement of shapes.*

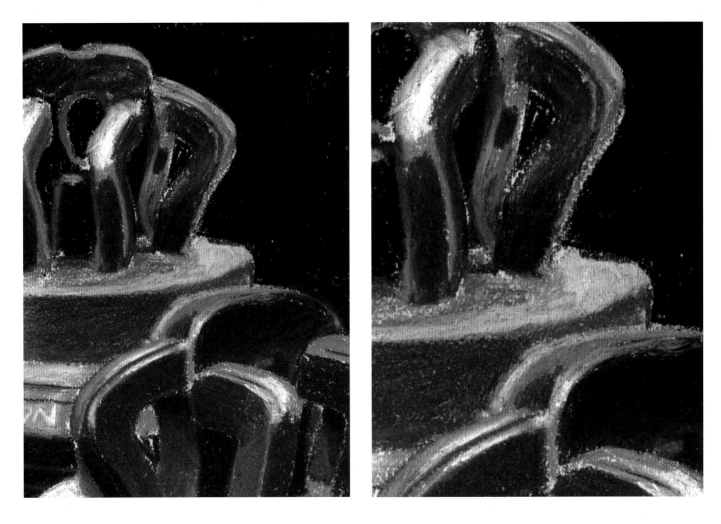

objective, where the subtle arrangements of shapes fit comfortably within the picture plane.

Looking at shape

Reducing everything to pure shape may help you to consider both positive and negative elements, making design decisions easier. One particular object might be placed in a dominant position; alternatively, an overall rhythmic pattern may be looked for, where no particular pictorial element is emphasised. Carrying out a few small, quick roughs before you start will help you in decision-making. A viewfinder is enormously useful in all of the separate aspects considered in this chapter, which collectively will make for a better awareness of compositional choices.

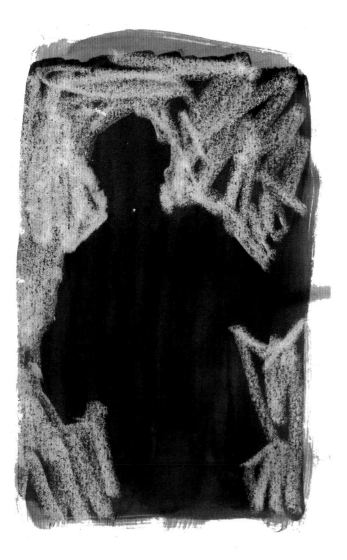

Negative space within a drawing

Much of what we look see is the 'negative' space around or between objects; focusing upon this will open up yet more ideas for interesting compositions, and create a high level of interest. You may consider making a drawing that features the negative spaces alone. The usual art school exercise for this is to draw the shapes that occur between the legs of a pile of chairs and stools; it is particularly effective if you steadfastly disregard the objects and draw only the negative shapes in relation to each other. The finished drawing will, if accurate, define the absent items.

Emphasis within a composition

Focus can be achieved by emphasising a particular object or shape, directing the viewer's attention to a particular compositional element.

4.6 ABOVE LEFT Jane Stobart, Focusing on the Negative, *chalk drawing on black ink wash, A4 (297 x 210 mm). This drawing carves out the shape of the head by defining negative space.*

4.7 ABOVE RIGHT Jane Stobart, Southwark Bridge, *ink washes on Khadi paper, 11.6 x 8 cm (4¹/₂ x 3¹/₄ in.). A sliding scale of tonal strengths or lines can create the effect of receding distance in a drawing.*

4.8 OPPOSITE Jane Stobart, Three Bells, *pencil drawing, A3 (420 x 297 mm). A drawing with no particular compositional emphasis.*

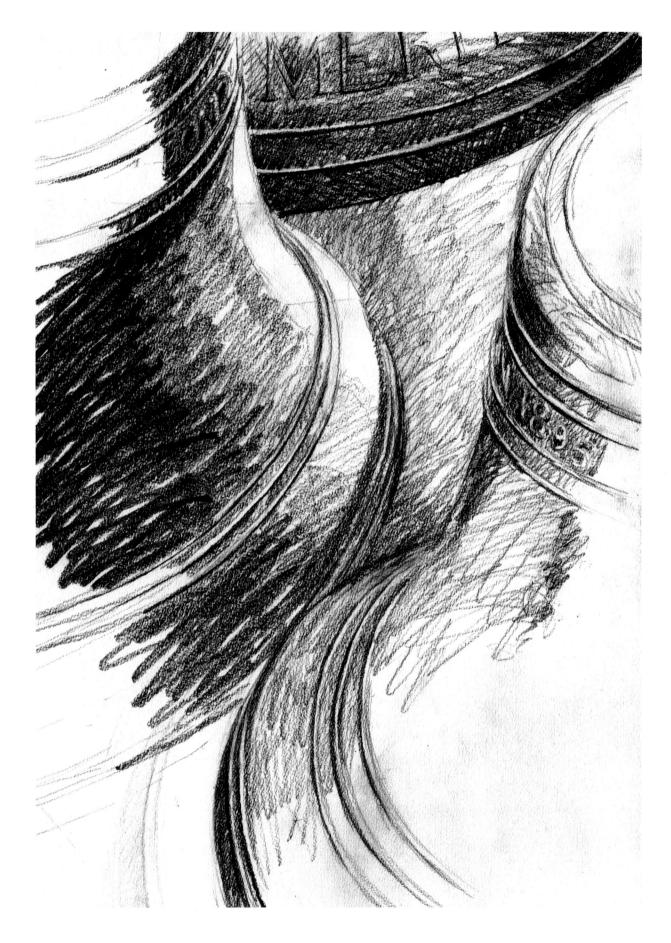

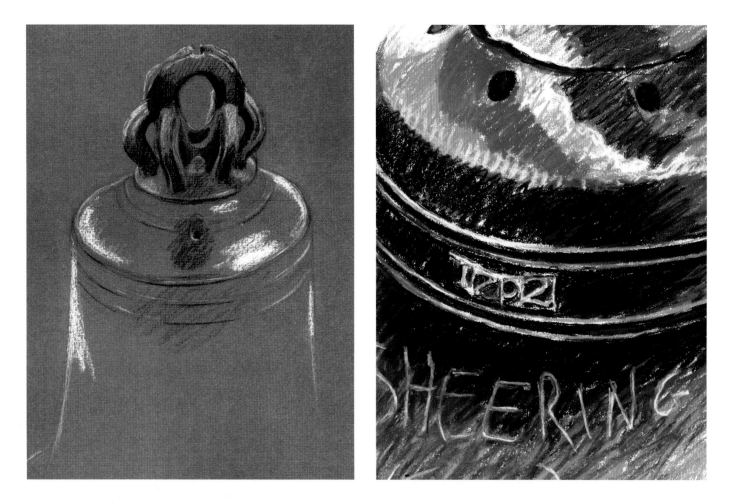

This can be attained both through the careful placing of an object within the picture plane and/or through the use of stronger line, lighter or darker tone, strong colour or larger scale of mark. Experiment with the contrasting treatment of a medium such as oil pastel, which can be blended for softness, thus pushing objects further away, or used to create dynamic marks, to give the illusion of a position closer to the viewer.

4.9a, *4.9b* ABOVE AND RIGHT *Jane Stobart,* Whisper (LEFT) and Shout, *contrasting viewpoints of a similar subject. See 'Exercise in creating visual opposites' on p. 66.*

Rhythm

A viewfinder can assist you in selecting an area with no specific dominant elements, focusing upon an overall visual rhythm and creating a pattern of movement within the composition. Select an area which offers few clues to the context of the objects – e.g. a busy subject such as an area of pebbles on a stony beach or a fallen pile of bricks; or a close-up of a leafy shrub, where the structure and direction of the leaves offer a sort of structured chaos.

4.10 OPPOSITE Jane Stobart, Junk Shop, *soft graphite drawing, A3 (420 x 297 mm).*

Exercise in creating visual opposites

This is an interesting image-making exercise, which will result in a pair of related yet totally different drawings; it seems to work particularly well with a still-life set-up. With the aid of a viewfinder, select two areas from the same subject. The point is to create two compositions that are poles apart in every conceivable way, producing the visual equivalent of a shout and a whisper (see p. 64).

(see p. 64)

To carry out this exercise successfully, you will need to consider all the separate aspects mentioned in this chapter – i.e. scale, shape (both negative and positive), juxtaposition (the relationship of one object to another), emphasis, rhythm, symmetry, etc. Consider also how your choice of drawing medium and its application will influence the desired contrast between the two drawings.

It will help to make small roughs of some ideas at the outset – say, three for the dynamic compositions and then three more for the quieter, more passive compositions. From these roughs, select the pair which make the most successful opposites before embarking on the two larger pieces of work. Try constructing a still life set-up using neutral objects, or black objects, or only primary colours. (See Chapter 2, sections on colour, neutralising and mixing a black.)

An idea for a series of drawings

This drawing project will really force you to think about the power of communicating through composition alone. There's quite an art to setting up a good still-life. You need to consider the juxtaposition of shapes, colours and textures, as well as thinking carefully about the vertical and horizontal aspects of the design (rather as a window-dresser would). Here's a drawing project that will put you in the position of arranging the objects to be drawn with the aim of creating specific types of compositions.

Select a group of items, such as a set of tools (spanner, pliers, hammer, etc.), cooking utensils, or a colourful selection of pick'n'mix sweets. Arrange these objects together in various combinations and juxtapositions in an attempt to communicate each (or a selection) of the following words: orderly – dynamic – powerful – chaotic – muddled – massive – delicate – rhythmical – solid – strong – jagged – sparse – minimal – complex – claustrophobic. Using a sketchbook, make a drawing of each arrangement, depicting either the whole or a selected part. A viewfinder may be helpful in this exercise. Use one approach – either line, tone or colour – so that the drawings will hang together as a set.

Chapter 5

MEASURED DRAWING AND PERSPECTIVE

To make an accurate drawing that creates an illusion of depth you will need some knowledge of perspective and a system of measuring what you see. The proportions of objects, the distances between things and perspectival scale changes can all be gauged in relation to each other, once you have grasped the simple method explained in this chapter.

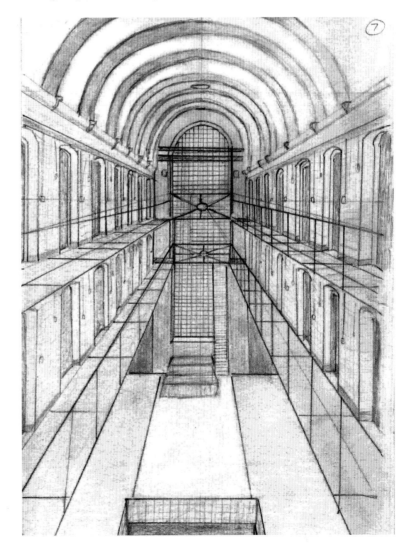

5.1 Roger Mehtab, The Prison Landing, *pencil drawing, 38 x 29.7 cm (15 x 11¾ in.).*

Even experienced artists may check the accuracy of relative proportions many times during the process of making a drawing.

Measuring

The following method is tried and tested and can be used from the outset of a drawing, or to check accuracy at any time. From a fixed point (i.e. sitting or standing on exactly the same spot) completely extend your drawing arm straight out from the shoulder, while holding a pencil. It is very important that your arm is not bent at the elbow at any time, as this will alter the scale of the measurements you are about to make. This method is tried and tested, and may be used from the outset of a drawing, or to check accuracy at any time.

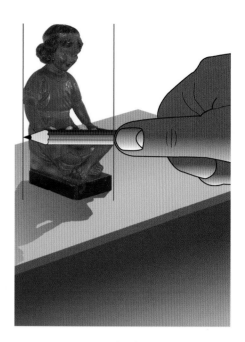

5.2 Using one end of your pencil and your thumbnail, measure the width of the object, keeping your pencil horizontal and one eye closed. Illustration by Mustafa Sidki.

- From a fixed point (i.e., sitting or standing on the same spot) completely extend your drawing arm straight out from the shoulder, while holding a pencil. It is very important that your arms does not bend at the elbow at any time, as this will alter the scale of the measurements you are about to make.
- Using one end of your pencil and your thumbnail, measure the width of the object, keeping your pencil horizontal and one eye closed (see fig. 5.2).
- Holding this key measurement with your thumb, see how many times it fits into the height of the object, keeping your pencil vertical. In this case, the width fits a little more than twice the height (see fig. 5.3).
- A useful way of relating this information back to your drawing is to reduce the object to a rectangle, as shown in fig. 5.4. You can now begin to break down the rectangle into sub-measurements, such as the depth of the head (find out how many times this fits into the overall height). Break down the rectangle into a halfway point and see what lines up with this. Gradually, you will find all of the clues to proportions, which will result in an accurate drawing.

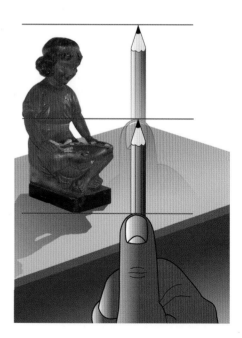

5.3 Using one end of your pencil and your thumbnail, measure the width of the object, keeping your pencil vertical and one eye closed. Illustration by Mustafa Sidki.

More complex subjects

Using the aforementioned method, objects placed in relation to each other in a still-life set-up, can be broken down into a series of simple but accurately proportioned rectangles, until you have established the correct relationships between the objects included in your drawing.

The first accurately measured object can be used as a key with which to compare the proportions of every other part of the still life, including the negative areas or spaces between.

5.4 *Holding this key measurement with your thumb, see how many times it fits into the height of the object, keeping your pencil vertical. In this case, the width fits a little more than twice the height. Illustration by Mustafa Sidki.*

5.5 RIGHT *Jane Stobart,* Junk Shop, *still life with alignment points, pencil, A3 (420 x 297 mm). The red lines applied to this drawing locate various clues regarding the horizontal or vertical alignments that occur between objects. See how the corners of a pile of books line up vertically with the edge of a fire surround below.*

This is a useful way to check the proportions of any drawing – e.g. you might measure the size of the head of your life model and then see how many times that measurement fits into their torso or total height. (See fig. 7.6, p. 92.)

Lining up

Another useful tip when making an objective drawing is to use your pencil as a horizontal or vertical guide, in order to discover the relationships between the placement of different visual elements. Every aspect of what you are drawing will have a fixed relationship in space. (See fig. 5.1, p. 67, and also fig. 7.6, p. 92.)

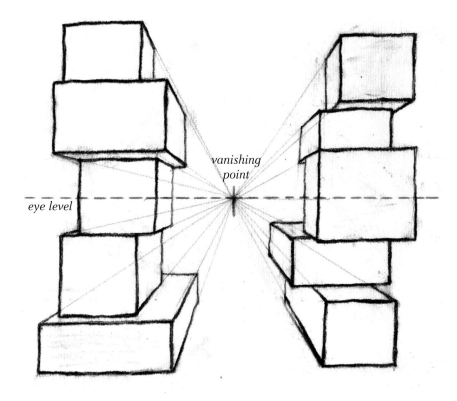

eye level

vanishing
point

Drawing in perspective

On a recent trip to Florence I saw a fresco by the Italian artist Masaccio, dating from the early 15th century. This image is claimed to be the first painting to demonstrate mastery of perspective, a technique that would change the face of Western art.

Perspective in a drawing will give the illusion of distance, as the size of objects diminishes as they get farther from the viewer. Perspective is an essential factor in all observational drawing, whether your subject be still life, architecture, landscape or a life drawing. In drawing a reclining figure, the all-important perspective is known as 'foreshortening'. This is often termed 'linear perspective', meaning geometric perspective, which makes use of a vanishing point.

1-point perspective

This term describes what you will see when drawing from a fixed viewpoint, with the subject/object set square to you. The usual example for this is a view taken from the middle of a straight road, where kerbs, street lights, rooftops, etc, which in reality are all parallel, appear to meet exactly at a central point on the horizon. The point of convergence is known as the 'vanishing point' and it occurs at your precise eye level (your personal horizon). A taller person

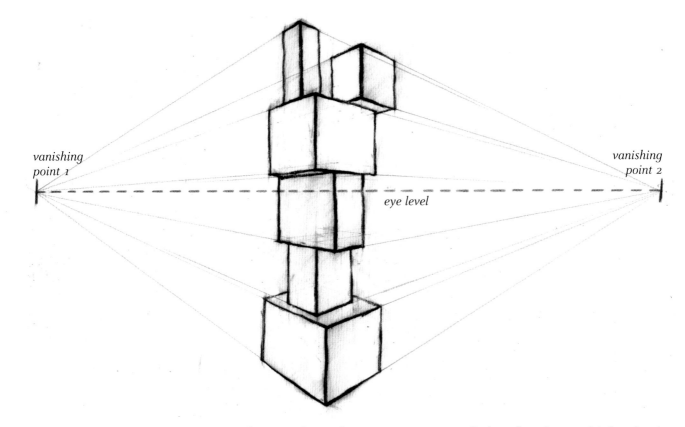

vanishing
point 1

vanishing
point 2

eye level

5.7 Diagram of boxes – 2-point perspective.

drawing from the same position, will therefore have a higher horizon and vanishing point than yourself.

In order to carry out an accurate perspective drawing, you will need to adopt a fixed position and establish your eye level. It will be here that the various perspectival angles converge to the vanishing point. All the upright lines of the subject will remain as vertical, without noticeable distortion, unless of course you are dealing with extremely high structures such as skyscrapers or tall trees, which we will look at later. See fig. 5.6.

2-point perspective

The need for both left and right vanishing points will arise when the subject is set at an angle to you. Similarly, both vanishing points will occur on the horizon, at your eye level. See fig. 5.7.

3-point perspective

A taller subject, such as a tower block at an angle to you, will require three vanishing points – the third being a vertical that will appear in the very centre of your vision. The width of the top of a tall structure will appear somewhat narrower than that of its width at eye level.

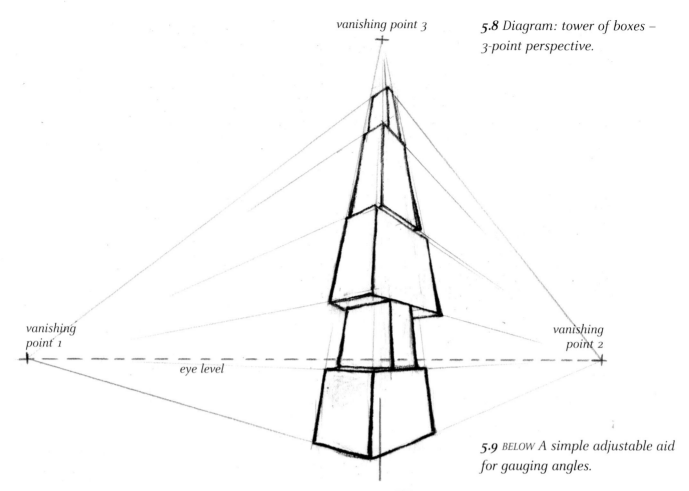

vanishing point 3

5.8 *Diagram: tower of boxes –
3-point perspective.*

*vanishing
point 1*

*vanishing
point 2*

eye level

5.9 BELOW *A simple adjustable aid
for gauging angles.*

Angled corners

Some students make use of aids in perspective drawing, by constructing 'angle guides' to assist them in gauging the correct angle of perspectival distortion. Holding one 'arm' of the device horizontally or vertically against the angle you are going to draw, adjust the other 'arm' to match the degree of the angle you're observing. The angle guide can then be placed on your paper to transfer (or to check) the angle you are drawing.

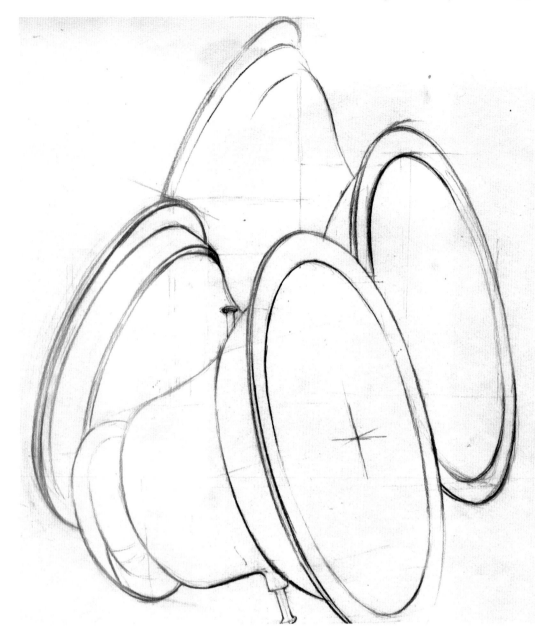

5.10 Jane Stobart, Bells, *pencil line drawing, A4 (297 x 210 mm).*

Circles in perspective

Cylindrical and conical shapes are subject to the same perspectival distortion as rectangular objects or cubes. A circle in perspective is known as an ellipse, and can be constructed by the same method of measuring, using the point of your pencil down to your thumbnail, described earlier. Simplifying an ellipse into a rectangular structure will help you to get the proportions of the height in relation to the width.

One of the most common errors in drawing an ellipse is to make it the shape of an eye, with sharp corners on either side. An ellipse should always be constructed as a continuous curve, however narrow the proportions.

Find the proportions of an ellipse by measuring height compared to width, and construct a rectangle as outlined here:

1. With an outstretched arm and with your pencil held vertically, take the measurement of the depth at the very centre of the ellipse you are drawing.
2. Compare this with the width of the ellipse; see how many times it fits in.
3. Construct a rectangle to these proportions.
4. You can now construct an ellipse to fit into your measurements as shown.

The centre of the ellipse will not, strictly speaking, be positioned in the centre of your vertical measurement, as the lower half of the ellipse will be deeper than the top half.

To find the centre:

1. Extend the middle line upward until it meets your eye level.
2. From this crossing point, draw two lines straight to the lower corners of your drawn rectangle.
3. You will now have created a new, inner shape; make a cross from corner to corner as shown. The centre of this cross will be the centre of your ellipse.
4. Draw a horizontal line through this point to touch each side of your original, drawn rectangle.
5. Now draw in the elliptical shape into your original rectangle using a smooth, continuous curve.

A drawing challenge

One of the most difficult drawing exercises that I have ever set for students is the drawing of a single piece of A2 (594 x 420 mm) cartridge paper on a tabletop. This will challenge your observation and measuring skills to the very limit; until you get it right, the paper will not appear to lie flat. Once you have successfully completed this part of the drawing, geometrical objects can be placed at intervals onto the piece of paper (e.g. a postal tube, a small box, a piece of wood) – some standing upright, some lying down – each drawn in line as if transparent.

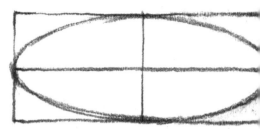

5.11 Diagram of how to construct an ellipse.

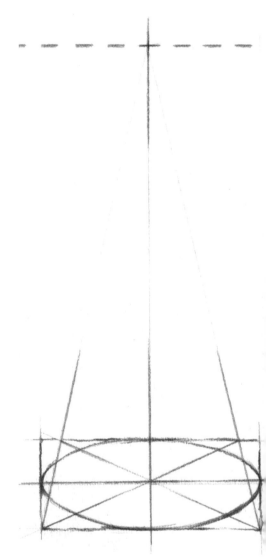

5.12 Diagram of how to find the centre of an ellipse.

5.13 OPPOSITE Jane Stobart, Gibberd Garden, Harlow, *Conté pencil drawing, A3 (420 x 297 mm).*

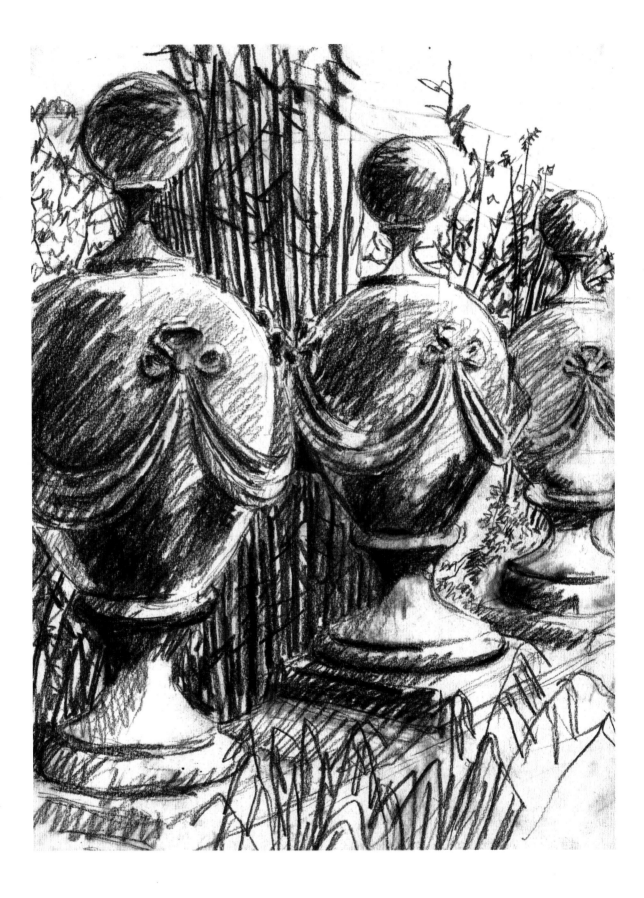

loads are transmitted by a shear upstand from the raft foundation around the periphery of the bottom slab of the vessel.

ACOUSTIC-VIBRATIONS.

mushroom

The head burrows through the soil propelling the soil behind it as it rotates at a terrific speed. As it pierces the earth surface it shoots into the sky at a given altitude fires ammunition in all direction in the form of red capsules. As they hit the ground they immediately spring into life working even faster than the parent once all the seeds have been dispersed the head drops to the ground and is dormant.

press up and down to bash the stone. The head rotates and lets loose stone fall between the gaps.

Rock rammer.

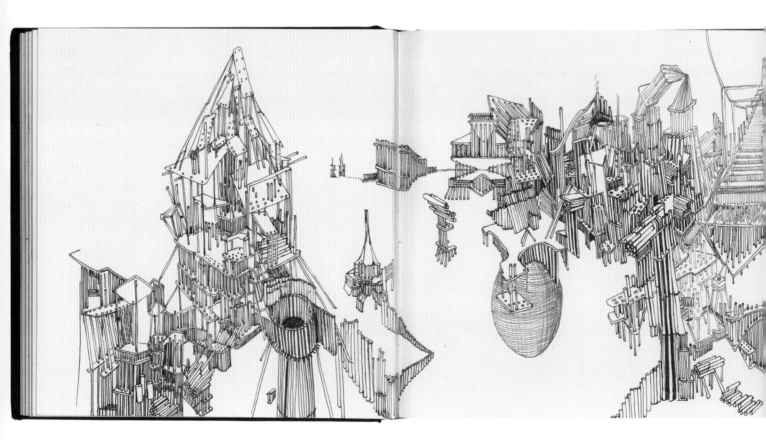

THE SKETCHBOOK

6.1 OPPOSITE *Ruth Uglow,* Machinery Spread. *'After visiting the diamond mines in South Africa I became interested in the machinery used to crush stone into rubble. Whilst drawing the stone-crushing machines at the Science Museum in London, I noticed similarities with certain flowers and seedpods. This led me to make a connection between the explosive dispersal of seeds and military warfare.'*

6.2 OPPOSITE *Ruth Uglow,* Wicker Settlement Spread. *'Inspired by the detailed coral in the aquatic tanks at Kew Gardens, London, I made a quick sketch on site and on returning to my studio tried to remember the structure with the aid of my sketch. I found it impossible to draw the coral as I remembered so continued drawing until my imagination took hold and I started creating a wicker settlement.'*

The sketchbook is an essential vehicle for many artists' research and development of their ideas. This chapter features seven artists who regard sketchbooks as an essential part of their creative process. Often neglected in art schools, sketchbooks can be thin and incoherent. A useful suggestion is to have a few on the go at any one time, keeping each for a specific purpose. This will consolidate themes and ideas. Chapter 9 offers ideas for some unusual sketchbook themes.

Ruth Uglow

Artist Ruth Uglow has been awarded several major international travel scholarships, which have allowed her to respond creatively to her experiences of other cultures.

Ruth uses her sketchbooks for observational drawings, which are manipulated and reworked at a later date for major drawings and prints. 'I use the sketchbook as my personal space for having fun, pushing ideas in new directions, without any pressure. A small sketch can record so many memories, not only the visual but also sound and smell.' Often her most detailed pieces of work start as a thumbnail sketches. 'I use small drawings to work out the composition and lighting before starting a final piece of work, solving numerous problems before I begin. I write words or a description beside my work to remind me of thoughts I had whilst drawing; these can prompt new ideas at a later point.' Ruth often looks back through her old sketchbooks and remembers the things that really sparked her imagination. 'It is wonderful to see how an idea starts and how far it can be taken.'

Donald Rodney

At the age of seventeen, Donald Rodney made the conscious decision to treat his sketchbooks as an ongoing work of art that would develop throughout his life. He carried one wherever he went; during periods in hospital the sketchbooks became creative outlets offering him a temporary escape from confinement and pain.

Donald created 48 sketchbooks between 1982 and 1998. They bring together a range of personal, cultural and political influences from the mass media, lyrics from reggae and punk, and biblical quotations from his Pentecostal upbringing. With wit, intelligence and the breadth of his imagination, Donald moved his own experiences into a framework of a wider political context. (Joanna Banham and Adrian Glew, curators, Tate Britain.)

Ceiren Bell

Animation student Ceiren Bell developed all her concepts for a major piece of animation called Baobab using a single sketchbook. It became an essential extension of her thought process, and every idea, however slight, went into the book as a visual offering for subsequent development or rejection.

6.3 *ABOVE LEFT Donald Rodney*, I wasn't born yesterday but I'm 26 years when writing these lines; I'm 27 now but hope I won't be for long; Good Morning Britain, visual essays. *From sketchbook number 31, 1989/90, A5 (210 x148 mm) (Tate archive: TGA 200321).*

6.4 *ABOVE RIGHT Donald Rodney*, The Education of Mike Tyson; The Art of War; Dr Jekyll and Mr Hyde; Orpheus and the Underworld; The Means and Manner of Obtaining Virtue; Benjamin Franklin, *from sketchbook number 42, December 1995, A5 (210 x148 mm) (Tate archive: TGA 200321).*

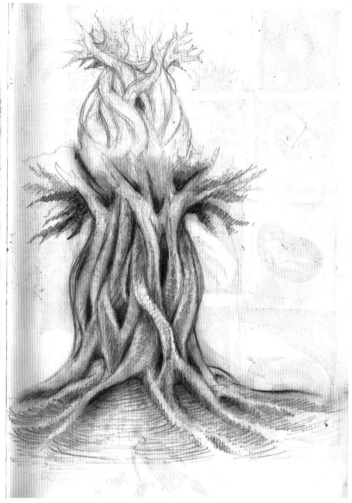

The foetus.
life & death are closely linked - foetus or
skeleton? life or death? is life under
oppression like some sort of death?

6.5 *ABOVE Ceiren Bell. A5 (210 x148 mm) sketchbook spread 1. 'The baobab tree was to play a key role in my animation, and I wanted it to look 'muscular' and sinewy, in the way that old trees do. I found soft pencil really liberating after working with ink washes; I often go between the two when I'm working in my sketchbook. The facing page was a practice run for the movements of the foetus, which were to appear at the roots of the tree.'*

6.6 *RIGHT Ceiren Bell, A5 (210 x148 mm) sketchbook spread 2. 'Ideas for an animation "morph", using ink washes, to try and ascertain which shapes worked and which ones didn't before embarking on the actual artwork.'*

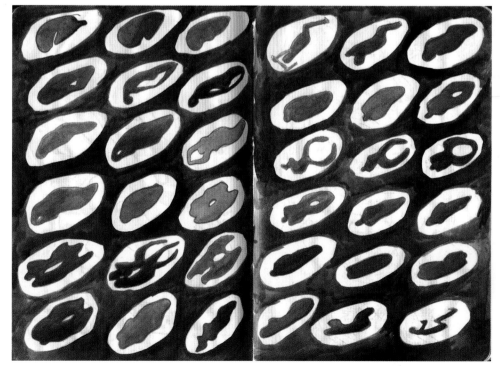

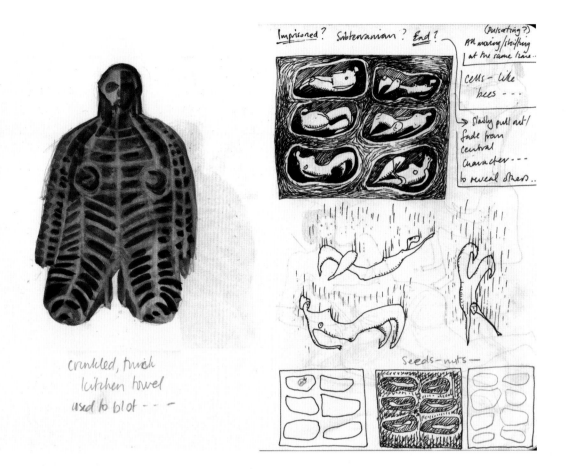

crinkled, thick
kitchen towel
used to blot - - - -

Imprisoned? Subterranean? End?

(Pulsating?)
All moving/shifting
at the same time..

cells – like
bees - - -

Slowly pull out/
fade from
central
character - - -
to reveal others..

Seeds–nuts –

Even without seeing the resulting animation, the sketchbook is a fascinating and beautiful documentation of a creative journey, made without inhibition in an experimental and inventive way.

'The keeping of a sketchbook was vital to my animation in many ways, not least because I needed to be absolutely sure something worked before committing the necessary time and energy that it takes to produce even a few seconds of animation (a minimum of eight drawings for each second produced). This was a good way of planning and developing my piece.

'However, the nature of a sketchbook – the fact that it is a sequential, pictorial record of all one's thoughts, ideas and influences, however small – means that it almost becomes an extended, static version of an animation itself. It actually ended up giving me foundational ideas for the momentum and movement of my piece, not to mention the juxtaposition of imagery.

'I deliberately chose a thick sketchbook with the cheapest paper so I would be encouraged to see it as a working tool, not a delicate work of art in itself, and wouldn't be too intimidated to mess around in it and see what came up. There are many more ideas in the sketchbook than I actually used, so I know that it will continue to be a useful resource, as well as an intensely personal document, for a long while yet.'

6.7 ABOVE *Ceiren Bell, A5 (210 x 148 mm) sketchbook spread 3. 'The "skeleton" was drawn first, and then I did a wash of Dr Marten's ink, blotting it with thick kitchen towel to give it a mottled look. On the facing page are ideas for the falling/burying sequence for the animation Baobab, made with Rotring pen and some thanks to Henry Moore!'*

Jane Stobart

My own sketchbooks divide neatly into two categories. I use A3 (420 x 297 mm) for making research drawings in industrial locations, which enables me to draw discreetly in a semi-public situation. Other, smaller sketchbooks I use specifically for experimentation and for formulating ideas for drawings or prints. I work in the small sketchbooks every day, combining images and thinking freely about potential ideas and formats (shape and dimension). I work loosely with a variety of media. The smaller size also enables me to draw on the tube or in any idle moment inside or outside my workshop. It is surprising how a quick idea jotted down often sparks off a train of thought for future development.

Everything that I do starts life in a sketchbook, and increasingly now I work from memory, which seems to make easier the promotion of ideas, while capitalising on the many years that I have spent drawing from life.

6.8 ABOVE Jane Stobart, spread from A3 (420 x 297 mm) sketchbook, drawings made on site at the Whitechapel Bell Foundry when tuning was taking place. The challenge here was to work quickly and attempt to capture the essence of the movement and action at a precise moment during the tuning process.

6.9 RIGHT Jane Stobart, spread from A4 (297 210 mm) sketchbook, where ideas for larger drawings or prints are played around with.

Anne Desmet

'As an artist-printmaker I specialise in making wood engravings, linocuts and collages, often of architectural subjects. The focus of my work shifts back and forth between Italy, (where I lived and worked as a Rome Scholar in Printmaking in 1989/90 and still revisit), and England, where I live now. My subject matter pulls in two directions: one body of work is essentially topographical but sometimes subject to metamorphoses; the other (suggested by the former) is concerned with urban myths, intuitive architectural fantasies and histories of urban destruction – such as the biblical Tower of Babel.

'My starting point is in sketchbook drawings (usually supplemented by photographs), where I get to grips with the structure and perspective of buildings or landscapes and, most particularly, the way the play of light creates sculptural illusions, dramatic shadows and highlights unexpected shapes and patterns such as the elongated splash of sunlight cast through the open-topped dome of Rome's Pantheon that brings the scene to life. I particularly enjoy sketching outdoors, from a high vantage point, to get panoramic vistas of rooftops and street plans. I usually draw in pencil and monochrome ink wash, watercolours or black pen. A small drawing can take me anything from half an hour to half a day to complete.

'I'm currently making drawings (such as fig. 6.10, opposite, in pencil and diluted black ink wash) of the extraordinary 1903 interior of the decaying Victoria Baths in Manchester (winner of BBC TV's first *Restoration* series), with a view to developing them into a series of prints and collages.'

*Anne Desmet's work can be viewed at www.hartgallery.co.uk

6.10 OPPOSITE PAGE, LEFT *Anne Desmet, Victoria Baths, Manchester, pencil and diluted ink wash, 28.5 x 9.6 cm (11¼ x 3¾ in.).*

6.11 OPPOSITE PAGE, RIGHT *Anne Desmet, Pantheon, Rome, pencil and diluted ink wash; 28.5 x 9.6 cm (11¼ x 3¾ in.).*

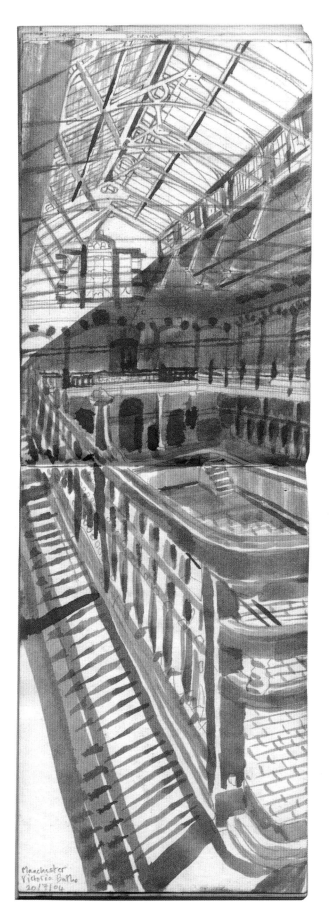

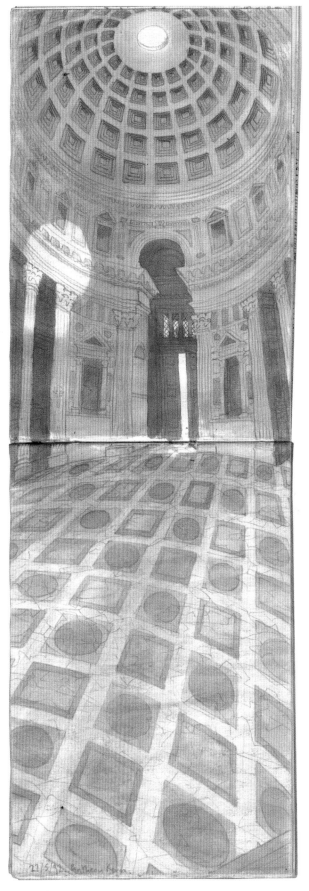

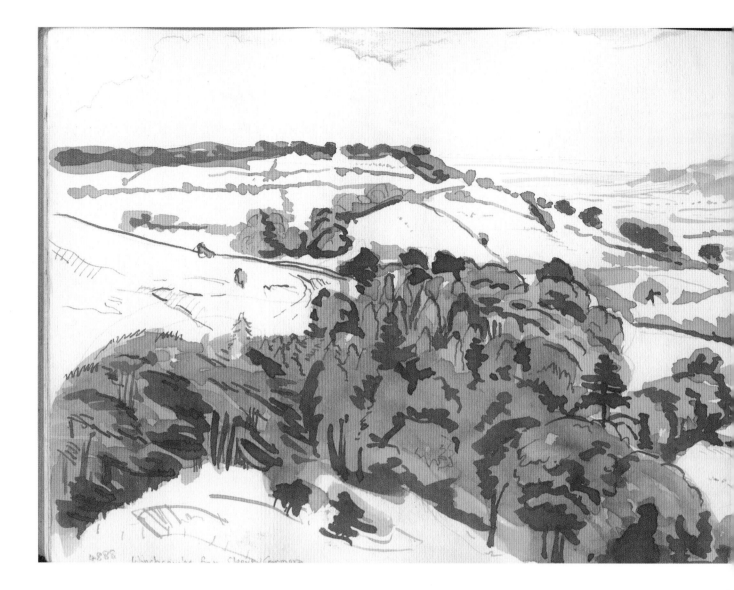

Roy Willingham

'I started using sketchbooks at art college, inspired by seeing Turner's tiny books and advised by a tutor that drawing every day was the way to become a proficient draughtsman. Although I fill books less frequently now, I am working on my 39th sketchbook, mostly of landscapes, and they have become a visual diary. Referring to drawings will call forth information from memory that often astounds me; the act of drawing somewhere embeds details in your mind far beyond those which are recorded on the page and of a very different nature to anything that can be recorded by a photograph. In fact, usually I avoid photographing somewhere I have drawn, as the image inevitably fails to match my perception of the view.

'How I draw is determined by my reason for drawing. For sheer pleasure I will make finished drawings with no intention of taking

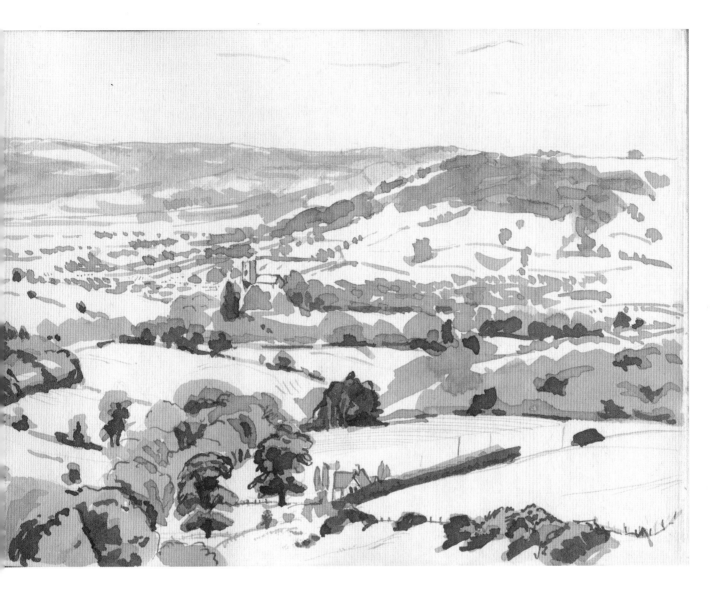

6.12 *ABOVE, LEFT AND RIGHT*
Roy Willingham, Cleeve Common,
Gloucestershire, 4th August 1988,
*steel-nib dip pen and diluted sepia
ink, 12.5 x 35.5 cm (5 x 14 in.).*

them further. Hasty sketches of a few lines will remind me of a composition and I will use a monochrome watercolour wash to note tonal effects or a sharp pencil to record topographical detail. Sometimes I will make written colour notes on a drawing while at others I will use small patches of actual colour. I will often make drawings of the same subject in various media to record different aspects, and occasionally produce more abstract drawings while at the location.

'My pads are small enough to fit into a jacket pocket (5 x 7 in.), and ring-bound so that they can be folded back while drawing, making them easier to manage. The paper is a 128 gsm cartridge, and I also insert other papers, like watercolour paper. I also tone full pages with watercolour in a new book before I start. I always work through the pad in page sequence and have a rule that no pages are taken out whatever the quality of drawing.'

reeds and
their reflections
Barragem de Serrão JA 13 Feb 2

Jacqueline Atkinson

Artist Jacqueline Atkinson records the world on her travels in a host of sketchbooks of varying formats and paper qualities. She carries an HB propelling pencil (always sharp), a fine-point technical pen, ball-point pens, a cartridge ink pen and miniature colouring pencils.

When travelling by car or public transport Jacqueline notes down fleeting glimpses of features such as flyovers, road contours, signs, forms on the horizon, hedges, animals, people, architectural details and effects of light. These 'notes in passing', sometimes with written references to colour, are a fount of ideas for prints, collages and paint-ings. She notes, 'Sketchbooks are a compact and convenient form in which to work, especially when travelling on a laden bicycle with only snatched moments for drawing. They become mini-portfolios. I make more detailed studies and can use larger-format books when my situation is stable.'

Each sketchbook becomes a treasure trove of personal memories and visual stimuli on themes such as 'ten wintry days in provincial Albacete in Spain', when her van broke down. 'To draw from observa-tion is to extract the essence of what you see and experience the dynamic changes as time passes. Drawing is second or even first nature to me.' Jacqueline uses several sketchbooks concurrently, relating to specific locations or themes. These often span a number of years.

6.13 ABOVE *Jacqueline Atkinson,* The Gestures of Natural Phenomena; Bulrushes and Reflections at a Small Dam in South-West Portugal, *fountain pen, (double-page spread) 11.6 x 28.4 cm (4$\frac{1}{2}$ x 11$\frac{1}{4}$ in.).*

6.14 RIGHT *Jacqueline Atkinson,*
Bulrushes and Reflections,
Rotring pen and Chinese ink
with watercolour, 11.6 x 14.2 cm
(4½ x 5½ in.).

6.15 BELOW *Roy Willingham,*
San Severino, Marche, Italy, 15th
June 1994, *carbon pencil and*
watercolour wash, 12.5 x 35.5 cm
(5 x 14 in.).

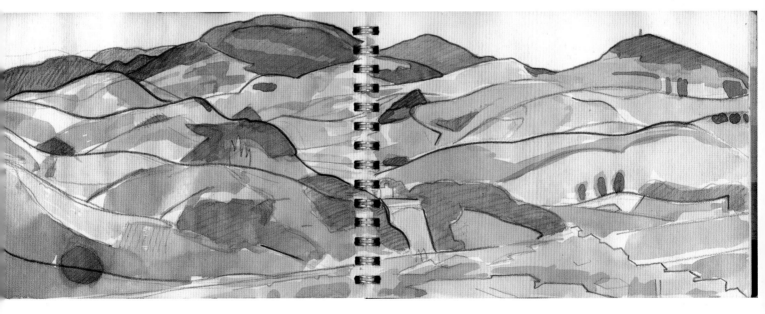

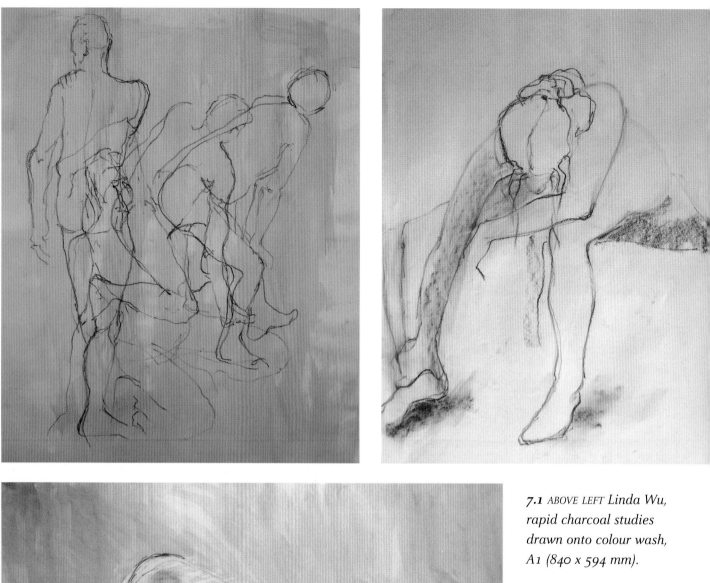

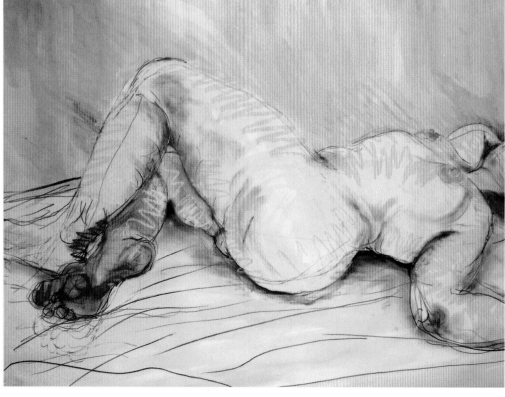

7.1 ABOVE LEFT *Linda Wu, rapid charcoal studies drawn onto colour wash, A1 (840 x 594 mm).*

7.2 ABOVE RIGHT *Wendy Mooney, delicate pastel drawing, A2 (594 x 420 mm).*

7.3 LEFT *Gillian Corderoy, mixed-media drawing, A1 (840 x 594 mm). With its heightened sense of colour, this drawing in response to a longer pose retains energy and vitality.*

Chapter 7

LIFE DRAWING

An evening class is the most obvious way to gain access to a life model, which is generally felt to be the ultimate drawing challenge. A good tutor will book a variety of models and set interesting poses ranging in duration from seconds or minutes through to several hours, challenging the eye and every perception that you have about drawing. The drawing issues discussed so far will have a marked effect upon a life drawing – considering the type of paper used, the medium, the scale, composition and approach all have a vital part to play. Years ago, knowledge of anatomy was felt to be essential for the student of life drawing in art schools, but these days it is generally felt that careful observation, together with an intuitive response to what you see, is the key to making inspired drawings.

Drawing tutors will encourage their students to look at other artists' life drawings, which can suggest ideas for your own work. See Chapter 3 for information on museum study rooms, which offer the opportunity to view original drawings by the artists in their collections. It is a privilege and inspiration to see great drawings at first hand.

Pose lengths

Having enrolled in a life-drawing class or gained access to a model, you can attempt a variety of approaches to drawing the figure, using a range of materials. Differing pose lengths will allow you to consider the aims of each drawing, as discussed in Chapter 3. For instance, very short poses will require a drawing shorthand or an intuitive, fluid response, which is also very useful when you are making quick visual notes in a sketchbook.

Longer poses will set a different challenge, enabling you to achieve full tone, colour or very detailed line drawings. There is no reason to assume that a lengthy drawing time will always result in a slow and meticulous approach; this is also an opportunity to work quickly and energetically, layering and building on your drawing, collaging, then drawing on top, mixing your media in all sorts of exciting ways that a shorter drawing time might inhibit.

The challenge of adopting a wide range of aims and objectives will have a beneficial effect upon your drawing skills, improving observation and knowledge of the human form while pushing the boundaries

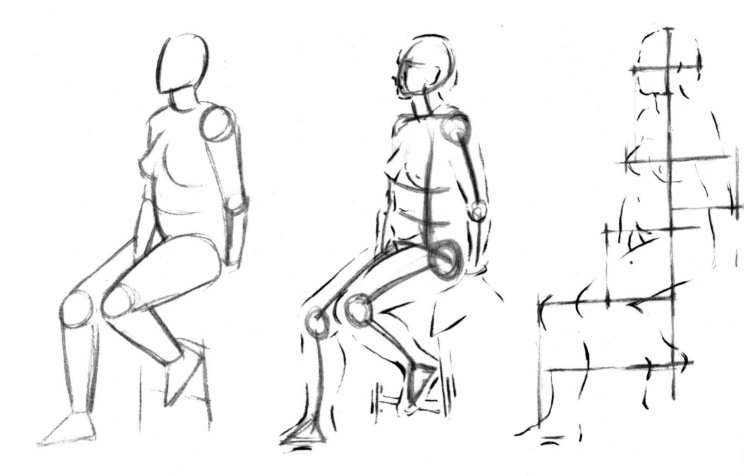

7.4a, 7.4b & 7.4c Jane Stobart, three ways of starting a life drawing. At the beginning of Chapter 5 (p.67) there is an explanation of a system for making a measured drawing.

of image-making. Attempting new and unfamiliar ways of responding to what you see will encourage an intuitive response to drawing the figure and to drawing in general. (See 'Challenge your perception', p. 52, for some suggestions.)

Starting a life drawing

Starting a life drawing can be daunting, but there are various ways of going about this that will leave the drawing open to adjustments and alterations, both great and small, at every stage of development.

- Draw lightly, and don't be too eager to cover your traces by erasing what you feel are mistakes. Even the most experienced will struggle with this drawing challenge, but the energy in a drawing can be lost in an attempt to 'neaten up' your final result.
- See the model as a series of basic shapes or building blocks, enabling you to take an overview of the whole figure. This will assist you in evaluating proportions, balance and alignment. Work in a light, loose and sketchy manner, which will keep the drawing flexible at every stage of development.

- Reduce the pose to scaffolding, with a series of lines that respond to the balance and gesture of the pose. Imagine you are roughing out the structure of the figure, which you will 'flesh out' later.
- Some artists will make detailed measurements and fix points onto the paper before attempting the drawing of the shapes and lines that will eventually make up the image. See the beginning of Chapter 5 (p. 67).

All of these methods for making a start on your drawing are valuable, and will force you to think and to look in different ways. When you are confident that your overview on paper is a fair representation of what you are seeing, you can begin to build onto your drawn framework with confidence.

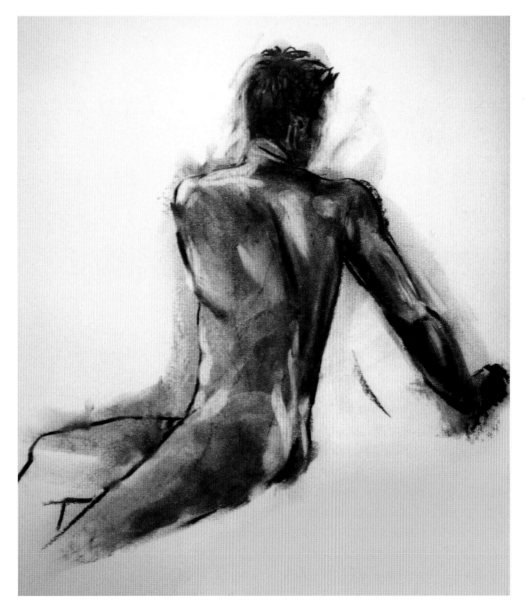

7.5 *Richard Morgan, charcoal and putty-rubber drawing, A2 (594 x 420 mm).*

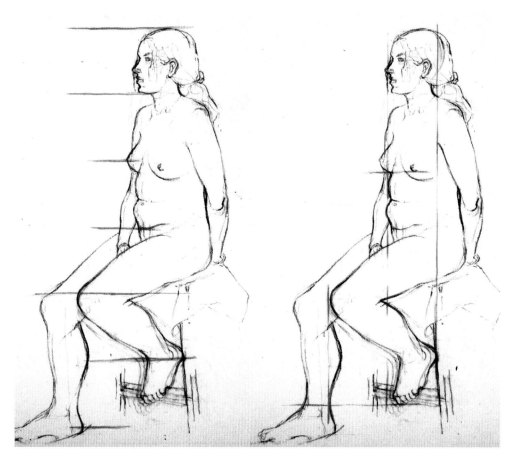

7.6 *Jane Stobart, pencil line drawing, A1 (840 x 594 mm), showing the measurement of the head, applied to the rest of the figure, and various points of alignment.*

Proportion

A system of measuring, as described in Chapter 5, p. 67, can prove invaluable when drawing from the life model, and can be used from the outset or to check proportions, etc. as the drawing develops. A key measurement, such as the depth of the life model's head, will assist in checking all other proportions (horizontal as well as vertical) (see fig. 7.6 above). The human head usually fits between seven and eight times into the adult standing figure. Of course, the head measurement can also be used to guage the depth of a sitting, crouching or reclining pose.

A key measurement, such as the depth of the head, can be used to relate to all sorts of measurements in your composition (horizontally, as well as vertically). Line up the tip of your pencil with your thumbnail, using a straight arm and closing one eye (see full description at the beginning of Chapter 5, p. 67). Now relate this measurement to other sections of the body, as shown. Note how this key measurement locates the point of the breast, base of stomach, knee and ankle. Also, establish any useful alignments by holding your pencil vertically or horizontally, which can indicate relationships in space. Note how a vertical line (see fig. 7.6 above) runs from the front of the face to the front of the torso and the back of the knee.

7.7 Wendy Mooney, charcoal and wash, A1 (840 x 594 mm). Quick drawings that perfectly capture the balance of the pose.

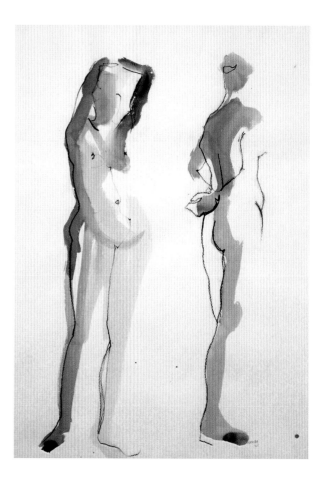

Balance

In addition to getting the correct proportions of the life model, it is important to understand the balance of the pose correctly, so that the figure is either stable and relaxed or intentionally taut.

Aligning points of the body vertically and/or horizontally with your pencil will help establish some all-important relationships in space. This will help ascertain where the balance lies and what it is that supports the figure. For example, in the case of a model standing with support firmly on one foot, vertical alignment will inform the person drawing that the weight-bearing foot is always directly in line with the head. In the figure supporting themselves with their weight equally on two feet, the head will be centred between the feet, forming a triangle.

Whatever it is that supports the body, try to observe the relationship between weight and support; this is vital in constructing correct and believable balance in a pose. Check to see how parts of the figure relate to other parts – e.g. head to foot, or head to chair leg, etc. – by holding your pencil vertically or horizontally, as shown in fig. 7.6 opposite.

Familiarity

Drawing tutors will recognise the fact that many students analyse and draw honestly and earnestly when confronted by the naked form, but will tend to slip into mannerisms and a degree of fiction when dealing with the human face. This is probably because of the familiarity one feels with this part of the anatomy, seen so frequently on a daily basis. It is vital that the student of life drawing strives to treat the head and face with the same principles as they do the torso, by concentrating on shape and form.

With line, you can break down the structure of the face by looking for changes in plane. Shadow is very useful in the search for form, highlighting the subtle changes of plane that occur.

Negative spaces

Drawing the negative spaces, such as the internal triangle formed by the hand on the hip, is a good way of viewing the body and will offer vital clues to assist your drawing. We see as much, probably even more, negative space when looking at a subject, so actually to draw it makes perfect sense.

The colour of skin

Colour in a life drawing has just as many possibilities whether the drawing is executed quickly or over a long period of time. A longer pose will offer an opportunity of studying the subtlety and complexity of skin tone, where an understanding of 'neutralising' will prove essential in achieving naturalistic colour – one of the most common problems is making the flesh colour too pink in the case of Caucasian skin tones. (See Chapter 2, p.40 for a basic understanding of colour mixing and how to tone a colour down.)

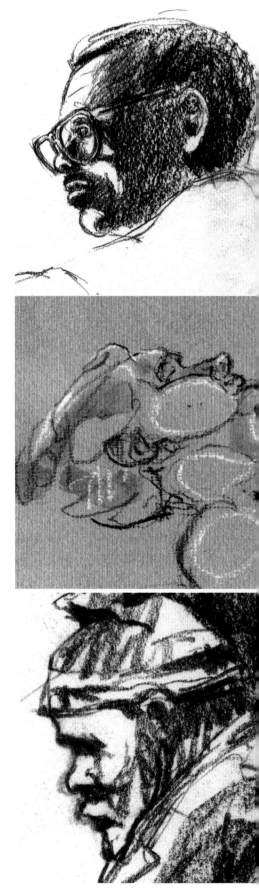

7.8 Flesh tones, oil pastel.

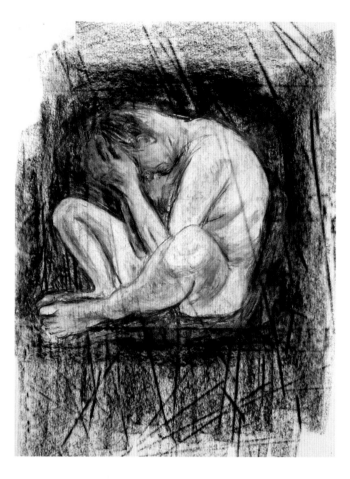

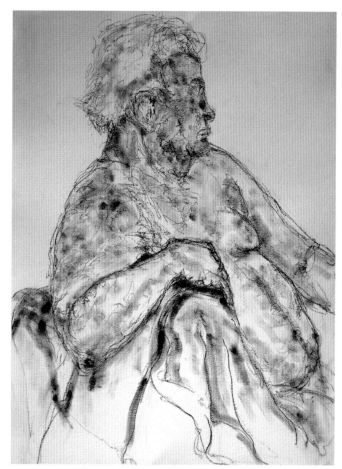

7.9 OPPOSITE Jane Stobart, Three Studies of a Head *(details), charcoal, charcoal and wash, Conté.*

7.10 ABOVE LEFT Noelle O'Kane, charcoal drawing emphasising the negative space, A1 (840 x 594 mm).

7.11 ABOVE RIGHT Jenny Dimond, drawing made with graphite and oil bars, applied with fingers, A1 (840 x 594 mm).

Shadow

Shadows will invariably be 'cool' and are bound therefore to need the addition of blue. This will help to give the illusion of receding areas, creating the appearance of depth. It is essential to establish the shallow distance between a person's chin and their neck when they are facing you. Look in the mirror at your own face and analyse what the difference is in the colour or tone.

Most colours that we observe are neutralised to some extent, due to the effect of light and shadow, and this is particularly important in life drawing. Use the knowledge that mixing complementary colours together will dull a colour (see Chapter 2, p. 40), making it less artificially bright.

The addition of black to a colour mix will have the tendency to kill your colour values, and is frowned upon by many painters. A very decent and far more interesting black, should you need to use it, can be made using pure colour. (See Chapter 2, fig. 2.18, p. 41.)

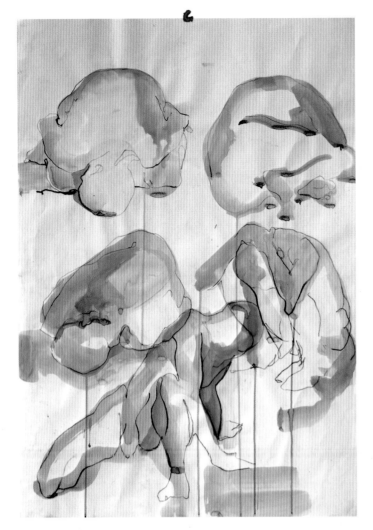

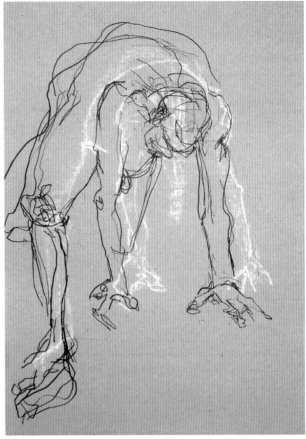

7.12 LEFT *Wendy Mooney, quick drawings carried out in charcoal and paint which capture the essence of these very short poses, A1 (840 x 594 mm). Without the time to construct or measure, Wendy develops an intuitive response to shape and line.*

7.13 ABOVE *Linda Wu,* Quick Study, *ink and chalk on sugar paper, A1 (840 x 594 mm).*

The life model in context

Learning to draw in a life class will open up a whole world of possibilities, sharpening observation, increasing your understanding of the human form and greatly improving technical skills, observation and drawing intuition. Chapter 9 suggests a variety of drawing subjects, many of which will involve the figure. Drawing in industry, at railway stations, on the beach, etc. will put into practice this specific knowledge and present a challenging contrast to the relative stability of the controlled life-drawing class.

Ideas for drawing from life

- Make several quick line drawings onto the same sheet. Adopt a different colour for each one and allow them to overlap.

- Work with a viewfinder (see Chapter 4, p. 58, fig. 4.3) to select a part of the figure (e.g. the torso) and make a larger-than-life drawing. Refer to your viewfinder until you have mapped the selected area onto paper, after which refer only to the life model.
- Ignore outline and detail by working with a brush and ink to express the gesture of the pose. This can make for an exciting sheet of drawings of quick poses.
- Create the silhouette of the life model by 'carving' them out of negative space with the side of charcoal, Conté, graphite stick or brush and ink. With a finer medium, work into the resulting silhouette with detail, contour, etc., to create a contrast of approaches.
- Try a combination of line and transparent washes of colour. Work freely with a transparent wash onto a pencil or ink line drawing; the line will remain, offering structure to the drawing. Reverse this approach by laying down the wash first, then working with line on top.
- Paint the model rapidly in clean or slightly tinted water, then add paint or ink to the watery 'drawing', allowing the colours to mix and run.
- Make a series of studies of your own face, using strong lighting – setting up the light source in various positions: from one side, from below, from above, from behind.

Higher-level drawing courses

There are now validated college and university courses where the student can pursue a passion for drawing as a main area of study. MA courses in drawing are now an option in several art schools in the UK. This is another sign that drawing is beginning to gain recognition in its own right, as well as being a primary specialism within the fine arts.

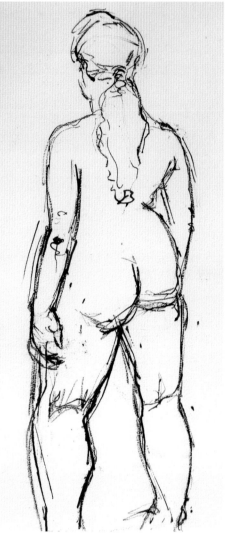

7.14 Jenny Dimond, Standing Figure, *drawn with ink and bottle dropper, A1.*

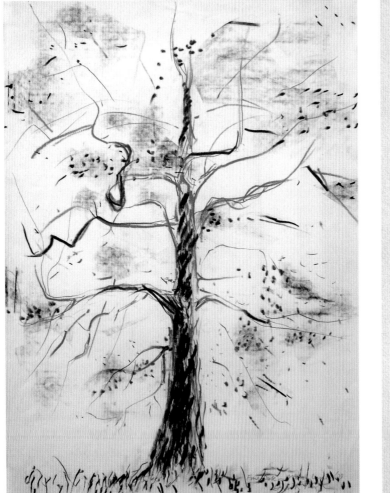

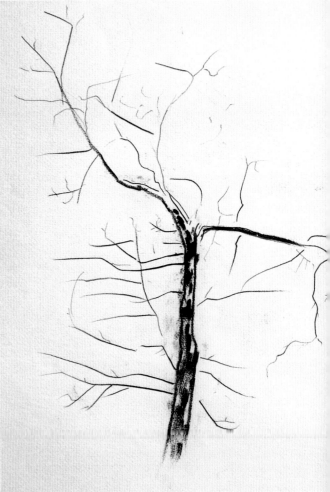

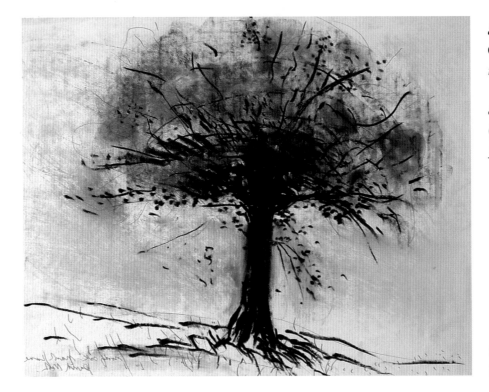

8.1 *ABOVE LEFT David Nash RA*, Fine Oak, Marsh Lane, *A1 (840 x 594 mm).*

8.2 *ABOVE RIGHT David Nash RA*, Elm (Deceased), Marsh Lane, *A1 (840 x 594 mm).*

8.3 *LEFT David Nash RA*, Moody Oak, Marsh Lane, *A1 (840 x 594 mm).*

Chapter 8

ARTISTS' DRAWINGS

Artists draw for all sorts of reasons, and usually their drawings are secondary to their main specialism. Until very recently it has been relatively rare to see an exhibition devoted solely to drawings, but this does seem to be changing. Perceived in the past as one of the art world's great secrets, drawing is at last stepping forward and gaining a profile more in line with other fine-art disciplines. The artists featured in this chapter discuss their relationship to drawing and the part that it plays in their work.

David Nash RA

David Nash RA is the UK's leading environmental sculptor. Working directly into dead trees with a chainsaw and blowtorch, he transforms them into inspired, inventive works of art that live on in a new form. He harms no living tree.

David also draws prolifically and sees drawing as being at the forefront of his work as an artist; he often exhibits his drawings and sculpture together, as an installation.

The drawings on p. 98 were made at the Gibberd Garden, Harlow, in 1979, where David carried out his first commissioned sculptures, made from the dead elms on the estate of architect Frederick Gibberd. He worked on a drawing board of his own invention, designed to accommodate the way that he draws. The device was comprised of a long, thick strap suspending the board from his neck and shoulder, leaving both hands free to make gestural responses to the trees that he drew. This simple but ingenious invention allowed the artist to draw in an intuitive and disencumbered manner.

David has a studio especially built and designed for drawing, where he documents ideas and forms for sculpture, or makes gestures and marks on paper for their own sake.

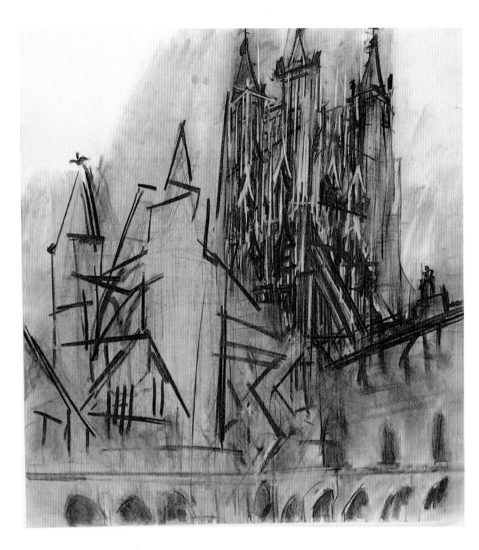

8.4 Dennis Creffield, Gloucester Cathedral: the Central Tower from the Cloisters, *charcoal on paper; 101.6 x 91.5 cm (40 x 36 in.). 'Gloucester is stunning – full of surprises and contrasts. Everything is exotic and far-fetched. Then you remember that it's a seaport when you stand at the north-east end, and it looms up over you like the elaborately decorated poop of some great silver galleon.' (Collection of the Los Angeles County Art Museum. Photo credit: John Holt.)*

Dennis Creffield

In 1987 Dennis Creffield was able to fulfil a dream of 40 years when the Arts Council commissioned him to draw all 26 English medieval cathedrals. From February until November of that year, he travelled around the country in a motor caravan: 'I visited all the cathedrals – most of them twice. Each day I drew them; each night I slept in their shadows, and their shapes filled my dreams.'

'I wanted to learn to draw at each cathedral – I wanted, if possible, to let the cathedral make the drawing.'

It was a massive undertaking, and Dennis encountered many unforeseen problems – for instance, too much foliage and too many tourists throughout the summer. However, he considered this opportunity a great privilege, and describes the experience as 'a pilgrimage of learning'. 'I find drawing extremely difficult. I don't do it because I enjoy it, but because it's the only way that I can understand things. Only drawing is real – and I only feel real when I draw.'

8.5 OPPOSITE Dennis Creffield, Worcester Cathedral: the Crossing from the North Transept, *charcoal on paper, 76.2 x 56 cm (30 x 22 in.). 'I didn't begin to draw the exciting structural articulation around the crossing until very late in my stay – it brought into my mind A.N. Whitehead's oracular and for me seminal statement: "It is the unity of volume which is the ultimate fact of experience, for example, the voluminous space of this hall."' (Photo credit: John Webb.)*

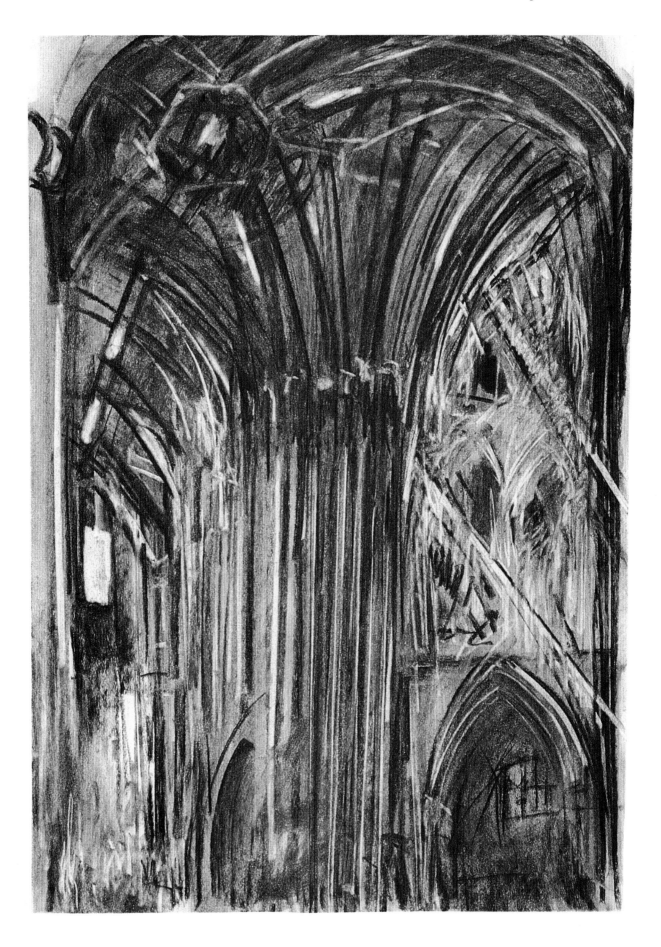

A varied selection of the cathedral drawings went on a national tour to municipal galleries from 1988 to 1990.

Mandy Bonnell

Artist-printmaker Mandy Bonnell is known for her beautiful artist's books, which can be found in many high-profile collections around the world. Since 1990, her work has been based upon a sense of place: that place being Lamu island off the north Kenyan coast, where she helped set up a printmaking workshop for Kenyan artists. Since then, through sponsorship support, she has run a series of ongoing outreach printmaking workshops.

Living and working in Nairobi and Lamu for three months most years since 1990 has had a profound effect on the way Mandy approaches her work. Lamu is predominantly African Muslim and historically an island of trade – with links to Arabia, India and Europe – from where there flowed exotic cloth, pottery, jewellery, perfumes and spices which were brought across the Indian Ocean by dhow. This sea trade influenced Lamu's unique characteristic, which mixed cultures and identities.

'Drawing using traditional materials is prominent and, by working in sets and series, the move into producing artist's books was a natural progression. Each series of work uses both drawing and print, and

8.6 Mandy Bonnell, Beetles, pencil and crayon drawing on Somerset Satin paper, 35 x 35cm (13¾ x 13¾ in.).

8.7 ABOVE *Mandy Bonnell,* Stick Insects, *pencil and crayon drawing on Somerset Satin paper, 35 x 35cm (13¾ x 13¾ in.)(detail).*

8.8 ABOVE RIGHT *Mandy Bonnell,* Millipedes, *pencil and crayon drawing on Somerset Satin paper, 35 x 35cm (13¾ x 13¾ in.).*

aims to produce a personal, intimate journey combining pattern, decoration, shape, form and space with figurative and abstracted elements, incorporating a narrative form to document and understand the changing patterns of identity, with a developing awareness of understanding the difference between African and European views of culture and nature.

'Drawing a clean, clear line across a piece of good-quality paper is a real pleasure; it is both my starting and finishing point. Drawing on a metal plate and etching into it, or drawing then cutting across an end-grain block, is still drawing, but it is a way to make a mark or a line that cannot be made in any other way.

'Scale is an important element, and it is comfortable and natural to me to work on a small scale; this reinforces the intimacy between the object, the resulting image and myself.

These insect drawings are the working drawings for a resulting artist's book. The original drawings were all drawn from life in Kenya, a single insect on a page, usually actual size as I find changing scale difficult at this stage. These very small drawings are brought home and pinned up along the studio wall, where they can live for several months so that ideas and thoughts can slowly evolve. Then, when I start to work on the book, the drawings are familiar and my ideas

firm. These very small single images will be redrawn in actual size of the finished book and become the working drawings for the resulting prints, where they will change again as they are redrawn and etched. The whole process from start to finish can take up to three years, as the images have to work within themselves as a visual statement and the book format has to be relevant to the content.'

William Kentridge

South African artist William Kentridge is involved in many areas of the visual arts. Drawings are a primary part of his creative output, and he also works in a wide variety of printmaking processes. He has been the inspiration behind many theatrical productions, which includes close collaboration with the Handspring Puppet Company in Johannesburg. William is also an amazing animator; his frame-by-frame technique involves shooting a drawing, then creating the next movement by erasing, redrawing, then shooting again. The results are astonishing – drawings that come to life with traces of the preceding, erased images. He calls his animation work 'drawing for projection'.

His large-scale drawings are usually carried out in charcoal and pastel. 'Arriving at an image is a process, not a frozen moment. Drawing for me is about fluidity. There may be a vague sense of what you're going to draw, but things occur that may modify, consolidate or shed doubt on what you know. So drawing is a testing of ideas; a slow-

8.9 William Kentridge, Untitled, *charcoal on paper, 214 x 498 cm (84 x 199 in.).*

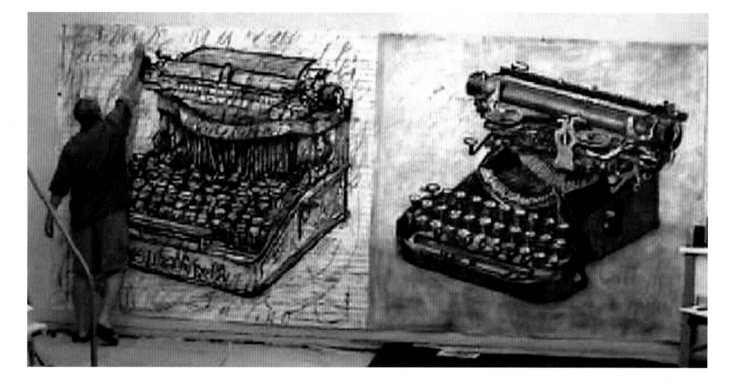

8.10 William Kentridge working in his studio in Johannesburg.

motion version of thought. It does not arrive instantly like a photograph. The uncertain and imprecise way of constructing a drawing is sometimes a model of how to construct meaning. What ends in clarity does not begin in that way.'

All of the artist's work is about his experiences and surroundings in Johannesburg. 'I work with what's in the air, which is to say a mixture of personal questions and the broader social questions.' He feels that all of his work is rooted 'in this rather desperate provincial city'.

Judy Groves

Judy Groves draws for all sorts of reasons, sometimes as a preliminary step to working in another medium, such as paint or clay. 'Drawing can be a very intense investigative process. But it often then develops into something in its own right, whether this was the intention or not.'

Over the last two years Judy's work has changed from abstraction to figurative. 'This has altered the way in which I use sketchbooks, which have become more like conventional notebooks, full of written ideas and diagrams. My reluctance to make small drawings in a book is to do with having been a book illustrator. I now prefer to make any preparatory drawings of ideas on large sheets of paper and pin them to the wall.

'I like to use inexpensive materials for drawing and would find working on beautiful and expensive paper very inhibiting. I therefore buy rolls of wallpaper lining paper – the thickest I can find – and

8.11 Judy Groves, Double Uncle, *sanguine and black soft pastel, 35.5 x 45.5 cm (14 x 18 in.).*

simply tear off as much as I need. I like the fact that this paper isn't pure white and that it yellows even more over time. It also has the perfect surface for the way I draw, with just the right amount of roughness to hold charcoal and pastel very well.

'Drawing allows me a freedom that I can't seem to find with other mediums, apart, that is, from modelling with clay. These two activities seem to me extraordinarily close: the layering, erasure, moulding, softening, blurring, defining, building up, taking away. Both processes are equally hands-on.

'I like to begin a drawing using soft black pastel, and would normally choose from a middle-price range because they crumble less. Sometimes, though, I need the unrivalled sootiness of Schmincke, which is a very soft brand.

'Although I will begin the drawing with pastel, this really is just one of the tools I'll use. As well as fingers, rags and rubbers, I will use paper torchons to move the surface around and to produce pale marks, echoes of the forms they surround. I build up several layers this way, repeating the process of drawing with pastel, smudging, softening and erasure. Over the last year I have made a series of drawings of identical twins. This method of blending and blurring developed from working on this subject.

'I don't usually fix the work until the whole thing is completed, or almost. I like to keep the drawing very fluid with lots of possibilities right up to end. At this stage I might remove whole sections of continuous tone and replace them with something harsher or more varied. This is where the process is so very like modelling with clay: the drawing can be pushed this way and that, changes can be made intuitively, with parts of it being enlarged, or reduced, or removed, without any of this harming the finished work. On the contrary, the surface becomes enlivened as previous layers show through, creating tone and movement.'

8.12 BELOW, LEFT AND RIGHT *Judy Groves,* Portraits of Louis, *soft black pastel, 35.5 x 43 cm (14 x 17 in.).*

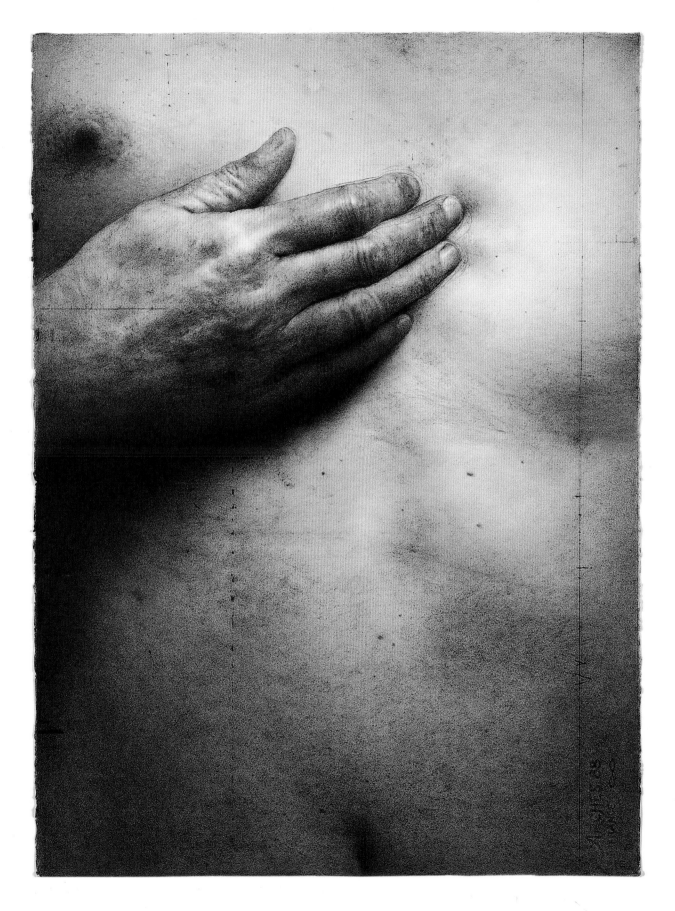

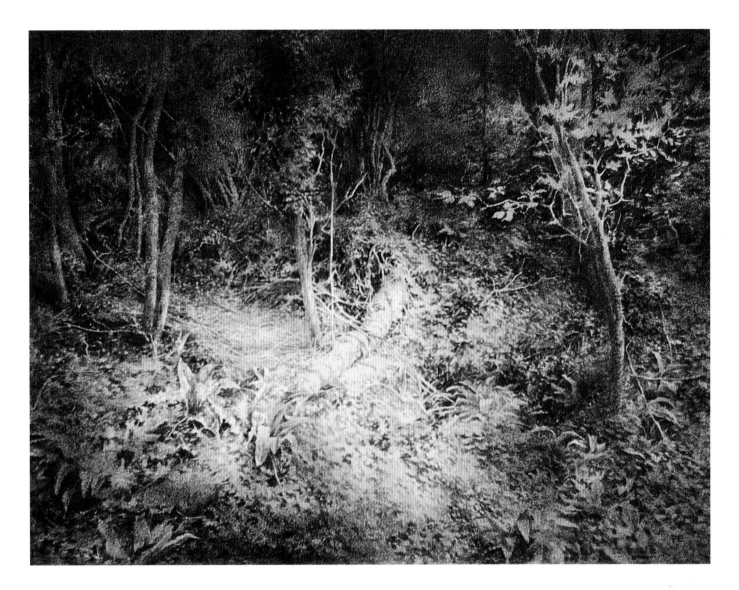

8.13 OPPOSITE Paul Emsley, Figure I, *chalk drawing, 77 x 57.2 cm (30¼ x 22½ in.).*

8.14 ABOVE Paul Emsley, Near Conkwell, *chalk drawing, 29.2 x 39 cm (11½ x 15¼ in.).*

Paul Emsley

Paul Emsley was born in Scotland, but for most of his life has lived in South Africa; he moved to England in 1996. Paul's work can be seen in most public collections in South Africa, and he has won a number of prestigious awards in major open competitions in the UK. He is represented by the Redfern Gallery, London.

The focus of Paul's approach to drawing is in revealing the sense of mystery and the primal, spiritual and symbolic qualities of his subject. 'I begin a drawing with line using a charcoal, chalk or carbon pencil. After building up the general shape and structure I use a finely ground chalk, which I apply with my fingers to a smooth paper to get the subtle transitions of tone I require. By rubbing the chalk over a period of time I can achieve the marks, folds and blemishes found on the surfaces of the forms. I have always found the drawings of artists most interesting,

especially those who draw in the perceptual or 'academic' way and who try to bring those skills to the contemporary world.'

Paul has always been fascinated by the surfaces of objects and the movement of light and shade over them. By emphasising this quality he aims to give a sense of mystery to his images. 'The principal way I try to convey those qualities is by emphasising the subtle tonal variations that occur across every form and surface. In the drawings illustrated, I viewed both the figure and the forest floor as surfaces over which light and shadow moved.'

8.15, *8.16*, *8.17* LEFT AND OPPOSITE *Tim Allen, drawings made with a variety of calligraphy pens and musical staff nibs, 40.6 x 50.8 cm (16 x 20 in.).*

Tim Allen

'Drawing was an essential part of the way I worked for many years, not as something preparatory, but as an end in itself. In 1990 I began making paintings using graining brushes and at this point drawing began to be so implicit in the paintings themselves that I stopped drawing as a separate activity. It was difficult to find or create drawing implements which could mimic the multiple-hatched mark of the graining brush, and so, after some failed attempts at strapping marker pens onto long-handled scrapers, I forgot about it. Some time later I came across the calligraphy nibs that these current drawings were made with, and this opened up all the possibilities of drawing for me again. In turn this has given me fresh ideas for painting, as the wide range of marks available with these pens has taken me beyond mimicking the brush mark and into new territory. Some aspects of the drawings remain the same as the paintings, most noticeably in the use of the white of the paper acting as the coloured ground so that the act of omission (of not drawing) creates the dominant forms.'

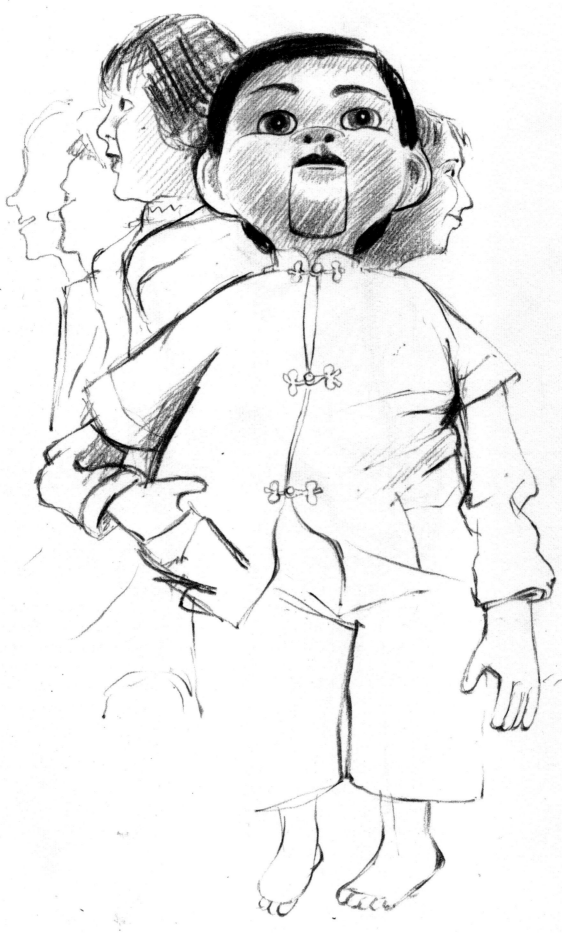

Chapter 9

THEMES, IDEAS AND PROJECTS

Outside the guidance of a college course or a drawing evening class, subject matter can be a problem for many people. Although it is undoubtedly the case that certain subjects will inspire a drawing, there is great potential in everyday life, and even in the domestic environment which offers the potential for some interesting drawing themes. This chapter offers suggestions for some unusual ideas, accessible to everyone. To discover what it is that engages you, it is a good idea to produce drawings in sketchbooks on an ongoing basis (see Chapter 6, p. 77).

Rarely can a creative idea be explored fully in a single piece of work. The best advice I was ever given regarding this was by a gallery owner many years ago, who told me always to work on groups of at least four related images. This obviously makes for a more coherent wall when hanging work, but it will also allow you to explore an idea or subject in several ways and from various points of view. A set of drawings or a thematic sketchbook will push an idea or subject considerably further.

Out and about

Gardens and parks are great places to draw, particularly if you are excited by exotic or architectural plants. Kew Gardens in London allows you into their hothouses to draw once you have a permit. It is wise, however, to check up on any possible restrictions before setting off for a public space where an entry fee applies. Many people are phased by drawing in public, but there are ways of doing this without becoming the centre of attention. An unusual and discreet position can make for interesting drawings and a less obvious viewpoint, as well as enabling you to view the world in more seclusion.

Factories and industrial works offer exciting and unusual subject matter. I have been fortunate to gain access to almost every place I've approached, so don't be afraid to ask, even though it can sometimes take time to gain permission. I usually spend months or years at each location, drawing once a week to build up both a good understanding and a large number of research drawings that I often develop into prints.

9.1 OPPOSITE *Jane Stobart,* Drawing of Ventriloquist's Dummies, *Bethnal Green Museum of Childhood, London, black pencil, A4 (297 x 210 mm).*

113

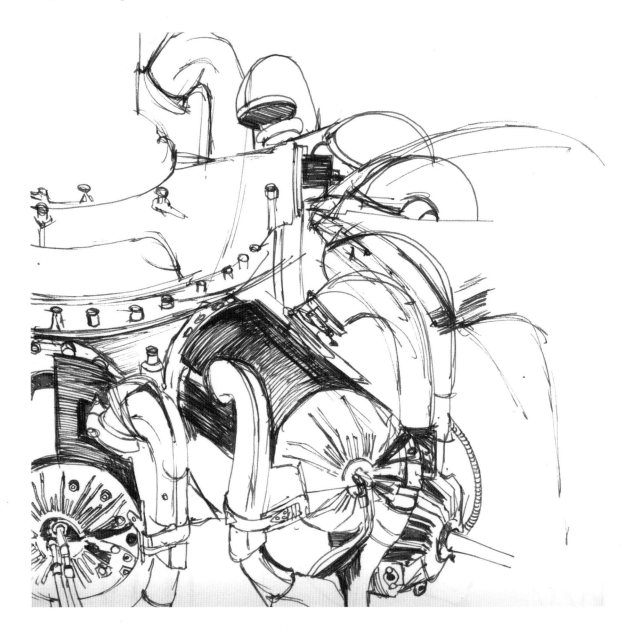

Garages, junk shops, mainline stations, packing stations, factories, building sites and tube-train maintenance depots may appeal to those seeking to draw large spaces, unusual settings or people engaged in work.

Swimming pools are excellent places to draw, but again permission must be sought. I have taken students on several occasions to make drawings from the local pool's public gallery. The lines on the pool bottom which move and change colour radically, subject to the amount of activity in the water, have the potential for an exciting series of colour studies, and will seriously challenge your observational skills. This is also a good location for some rapid and expressive figure drawings.

Drawing discreetly on the bus, the train or the tube in a small sketchbook can give a whole new experience to commuting. If you feel this is confrontational, try to look very hard and then draw directly

9.2 Ruth Uglow, Drawing of Machinery at the Science Museum, London, *ballpoint pen, 14 x 14 cm (5$\frac{1}{2}$ x 5$\frac{1}{2}$ in.).*

9.3 *Jane Stobart,* Bell Founder at Whitechapel Foundry, *charcoal study, A5 (210 x 148 mm).*

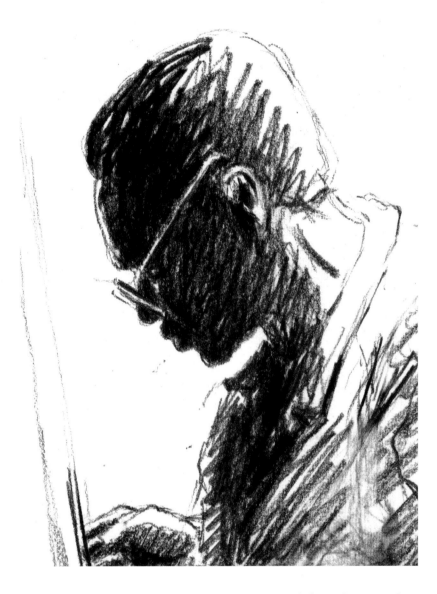

into the book from memory, as Henry Moore did in his London Underground Shelter Sketchbooks during World War II. Drawing (or photographing) on a large scale in train stations or on the London tube network will also require permission.

Making studies in **museums** is part of a normal art-school training, but individuals can also gain permission to do this, as long as they agree to work in a dry medium such as graphite or coloured pencils. Pencil sharpeners designed to catch the debris are recommended (if not insisted upon) for location drawing; many museums will offer collapsible seats to drawing students and artists. There are museums dedicated to all manner of unusual artefacts, such as lawnmowers, body parts, beam engines, etc. If you have access to a computer, type 'unusual museums UK' into a search engine such as 'Google', and see what it brings forth.

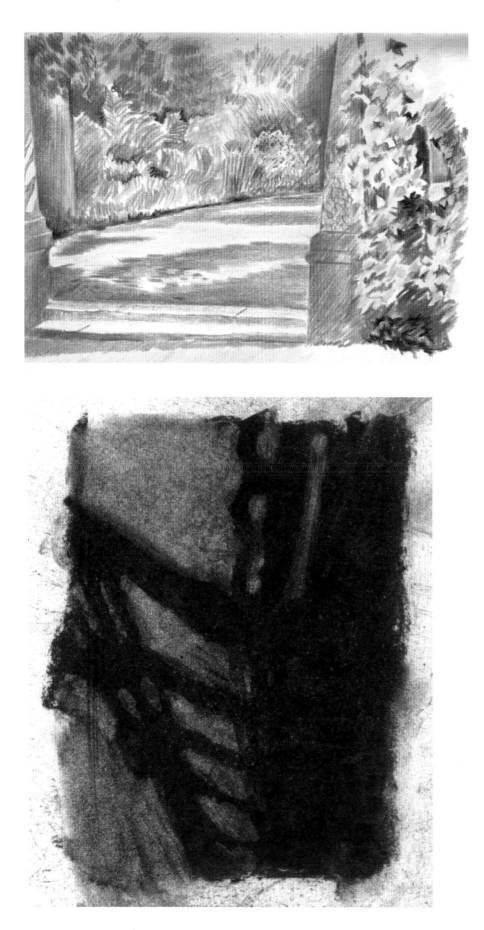

9.4 Robert Bramich, Garden Study, *coloured pencil, A5 (210 x 148 mm).*

9.5 LEFT *Jane Stobart,* Millennium Bridge, *charcoal drawing, 10.5 x 7.7 cm (4¼ x 3 in.). Look for an unusual viewpoint; this drawing was made from underneath the bridge, standing on the bed of the Thames at low tide.*

9.6 BELOW *Sairah Ali (student at Barking College), tonal chalk pastels on black sugar paper, A3 (420 x 297 mm).*

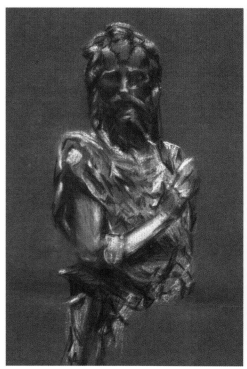

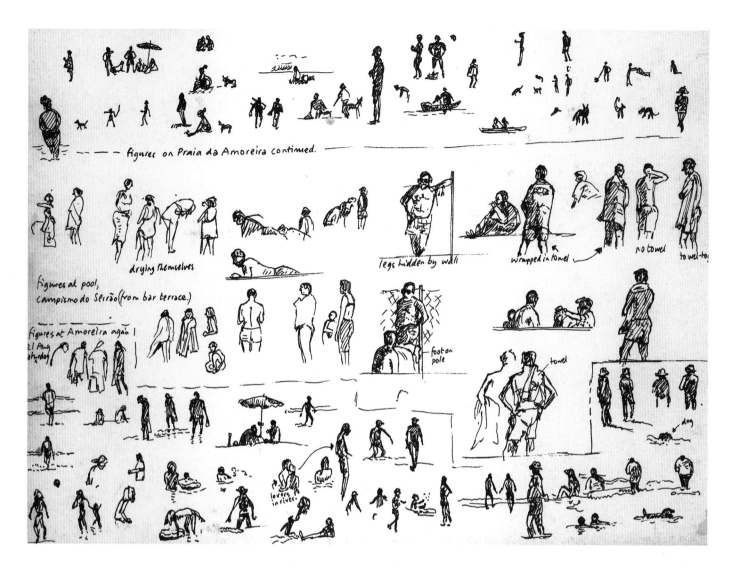

9.7 Jacqueline Atkinson, People on the Beach and by the Pool, *technical pen and Chinese ink, 14.8 x 20.8 cm (5¾ x 8¼ in.). The drama of people's stances and physical attitudes, their garments, accessories, postures and movements, noted down at a beach and pool near Aljezur, Portugal.*

Churches have appealed to many artists, offering access to vast interior spaces. Small local churches and chapels will offer some privacy if you are not confident in drawing publicly. Small details, reflected light or larger architectural aspects can offer rich pickings.

I have included several drawings of **bridges** in this book, this being an ongoing drawing project of mine. Starting with Tower Bridge, I have made several drawings and some quick studies of each bridge on this central stretch of the Thames.

Finally, following on from a life-drawing course, you might consider the subject of figures on the move – **dancers**, **athletes**, **horses**, etc.

Closer to home

There is no need to leave home to find interesting subjects for drawing: the **garden shed**, the **allotment**, the **greenhouse**, as well as **corners of your own garden** can all offer some potential. If you have

no garden, aspects of your home environment offer just as much scope for an inspired series for drawings or thematic sketchbooks. **Cupboards or drawers** can offer the organised chaos of an enclosed space. The shoes in the **bottom of the wardrobe**, **kitchen drawers** and the **sock drawer** all hold a potential tangle of good, strong shapes, lines and colours. **Clothes on hangers** are also visually interesting. American artist Jim Dine has made a series of works based on his dressing gown.

Dealing with the **internal spaces** within your own home may appeal to you. The **view through a doorway** will offer a framework for a drawing, perhaps revealing another open door to the room beyond. **Stairways** make a challenging subject, whether looking up or down. **Windows** form a similar natural framework for the world beyond.

Several years ago, in a dedicated sketchbook, I documented my **cat** throughout her pregnancy, at the birth and up to the weaning of her five kittens.

9.8 Jane Stobart, from Pregnant Cat Sketchbook, A4 (297 x 210 mm).

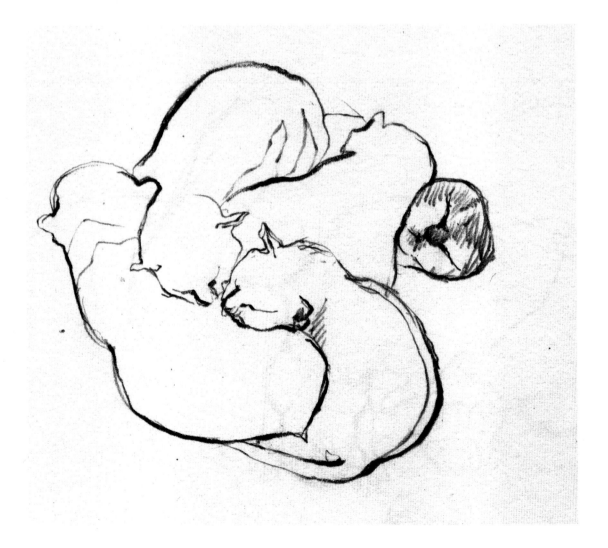

Drawing on a daily basis

Drawing the same subject on a daily basis is an interesting project, particularly if you are concerned with colour. The view from a window at different times of the day and night, or sky studies from a specific viewpoint, may offer surprising and dramatic changes, given the UK's unpredictable weather. Varying light conditions and the changing seasons will hugely affect the appearance of the same subject.

Making a sketchbook

A collection of different papers – wrapping paper, Manila envelopes, tracing paper, coloured sugar papers, etc. – all trimmed to the same size, backed with card and bound together, can make an interesting sketchbook. Some stationery shops and high-street printers offer binding services.

9.9 Jane Stobart, Abbey Mills Pumping Station, *candle wax and inks, 17.5 x 6.5 cm (7 x 2¹/₂ in.).*

PRACTICAL TIPS

This final chapter offers advice on some practical aspects of drawing: changing the scale; stretching paper; signing, mounting and framing; storing drawings; and some health and safety aspects when using air-borne materials.

Scaling up an image

There are several ways of scaling up a small image to a large or even massive new size. This can be achieved accurately by using one of simple techniques outlined below.

Squaring up

This involves drawing an accurate grid of squares onto your small image – use a tracing-paper overlay or a photocopy if you don't want to draw directly onto your original. If the image is small, a grid of 1-cm squares laid over the area that you are intending to enlarge will suffice. On a larger piece of paper, make a similar grid but use a greater scale for the squares. Now redraw the image square by square onto the enlarged grid.

Projecting

If you can get hold of an overhead projector, this is an excellent and quick way to enlarge an image. Photocopy your original onto photocopy acetate (which is transparent) and place this onto the bed of the projector so that the image is facing you. The light will project the enlarged image onto the wall, where your drawing paper should be secured. By avoiding your own shadow, you can trace the projected image lightly onto the paper to use as a guide for your final piece of work.

Enlarging/reducing using a photocopier

Another useful way of enlarging an image is to take a photocopy of your original – either at the same size or enlarging it up to the maximum the photocopy will allow onto one piece of paper. Draw a grid of rectangles onto the copied image at the ratio 4:3 and chop them up with a ruler and craft knife. Reassemble the image and number the squares. Now enlarge each square using a photocopier, making sure that your rectangular enlargement lies within the A4 or A3 photocopy that you print. Trim the enlargements and reassemble the pieces. Stick these together before tracing.

Percentage enlargement or reduction

To calculate the percentage of a specific enlargement or reduction for photocopying, carry out this simple sum using a calculator:

The dimensions you want (e.g. 76 cm high) divided by the existing dimensions (e.g. 42 cm high) multiplied by 100 = 181% enlargement. Therefore, key 181 into the photocopier. This method will also give you a reduction percentage, should you wish to make your image smaller.

Working from photographs

Artists usually have strong opinions for or against working from a secondary source such as photographs. I use photography occasionally as an aide-memoire, but in the kinds of places that I usually draw (which are often quite dark) my photographs are never good enough to be of much use! I actually gain more understanding about a subject by drawing it from life. There is no doubt that photographs can be extremely useful for visual information on specific detail, if drawing time is short.

Stretching paper

When you are working in a wet medium, a heavier weight of paper will be necessary to avoid cockling (buckling of the paper). Alternatively, any paper, from cartridge paper up to the heavier weights, can be thoroughly wetted and then secured to a wooden drawing board with gum-strip tape. When the paper dries it will stretch tight, enabling you to make a drawing using any wet medium. When the art work is complete and the paint is dry, the paper can be cut free of the board.

Soak heavier-weight papers (250 gsm upwards) in warm water for 10–30 minutes, in the sink or bath. The most common error in this

process is to overwet the gum strip (thus washing off the gum) or to underwet the tape (thus leaving areas dry, so the paper is not secured to the board). When placing the damp tape around the edges of the damp paper, rub it down firmly with a ball of tissue, to remove any air bubbles, ensuring good contact.

Signing drawings

There are various opinions as to whether or not drawings should be signed. I once sold an unsigned drawing in an exhibition, and the buyer insisted that I deframe it to add my signature. If you are signing and dating a drawing, be discreet and use a pencil, to avoid distracting attention from the image.

Tips on conservation

- Most paper nowadays is at least 'pH neutral', which means that any acidity has been neutralised to avoid the paper turning yellow or brittle over time. This can be checked with your supplier or shop.
- Store drawings flat if you wish to keep them in good condition, interleaving each one with a sheet of acid-free tissue paper. If you haven't got a plan-chest, a cardboard portfolio (the type with tapes you can tie) is excellent, and easy to store under the bed.
- Commercial fixative is designed to remain as a transparent seal on your drawing and will not yellow over time, while hairspray (which some people use as an inexpensive alternative to fixative) contains perfume and is not intended to conserve a drawing on paper! However, it is a useful alternative, and to an extent it works.

Health and safety

Many people are allergic to the chemicals in a fixative spray; even if you're not, airborne materials are a danger to the lungs. Always spray fixative in the open air if possible, or in a dedicated separate area or extraction booth. Avoid breathing in the spray.

Securing your paper to the drawing board

This will be a very obvious tip to many, but be aware that some masking tapes will be stickier than others and, if using these, you stand to lose the corners of your drawing when removing it from your drawing board. Look for 'drafting tape', a low-tack variation on masking tape, designed for this purpose.

Mounting and framing

When mounting work, use pH neutral (acid-free) board if possible, or 'archival' mounting board if you can afford it. If 'floating' a drawing (adhering it to mount board) or window-mounting, you will require some kind of adhesive tape. Tape guaranteed as 'archival' will guarantee that there is no long-term damage to the edges of your drawing paper. Acid-free tapes are not cheap but are highly recommended if your work is to be sold. The glue of regular 'sticky' tape will in time travel through to the front of the drawing paper, causing an indelible yellow-brown stain.

10.2 A simple, sturdy frame.

Before framing a window-mounted drawing, back it with a couple of sheets of acid-free tissue and a sheet of pH-neutral cartridge paper. The hardboard that most people use to back frames should be kept well away from the art work, as in time it may discolour the drawing.

Framing courtesy

It is advisable to keep frames to a neutral colour and a simple style and profile. This will complement your own drawing, and will also respect the work of others if your work is being exhibited in a group show. Showy frames will detract from the work and do not go down well with judges of open exhibitions. Your frames should be sturdy and finished off with gum strip on the back, to seal the whole unit.

BIBLIOGRAPHY

Kaupelis, Robert, *Experimental Drawing* (New York: Watson-Guptill Publications, 1992)

Metzger, Phil, *Perspective without Pain* (Ohio: North Light Books, 1992)

Rawson, Philip, *Drawing* (2nd edn) (Philadelphia: University of Pennsylvania Press, 1987)

Simpson, Ian, *Drawing, Seeing and Observation* (London: A&C Black, 1992)

SUPPLIERS

Great Art catalogue
web: www.greatart.co.uk
email: welcome@greatart.co.uk
tel: 0845 601 5772
Mail-order catalogue
for materials and paper.

Atlantis Art
7–9 Plumbers Row
London E1 1EQ
web: www.atlantisart.co.uk
email: mail@atlantisart.co.uk
tel: 020 7377 8855
For materials and paper.

The Works
web: www.theworks.gb.com
High-street bookshop (UK-wide)
that sells very inexpensive
artists' materials.

Paintworks
99–101 Kingsland Road
London E2 8AG
web: www.paintworks.biz
email: shop@paintworks.biz
tel: 020 7729 7451
Art materials and picture
framing.

T.N. Lawrence & Son
web: www.lawrence.co.uk
email: artbox@lawrence.co.uk
tel: 01273 260260
 0845 644 3232
Art suppliers with mail-order
business and shops in Hove and
Redruth.

R.K. Burt & Co.
57 Union Street
London SE1 1SG
web: www.rkburt.co.uk
tel: 020 7407 6474
Wholesale paper merchant.

John Purcell Paper
15 Rumsey Road
London SW9 0TR
web: www.johnpurcell.co.uk
email: mail@johnpurcell.net
tel: 020 7737 5199
Wholesale paper merchant.

INDEX

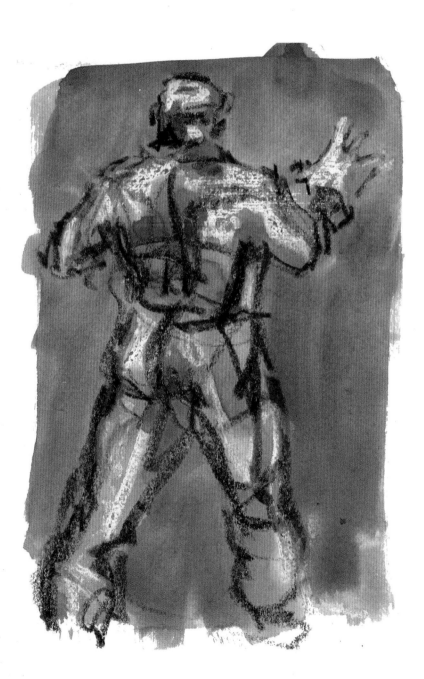